# PAUL CÉZANNE

KAREN WILKIN

WITHDRAWN

A TINY FOLIO™
ABBEVILLE PRESS   PUBLISHERS
NEW YORK   LONDON   PARIS

Front cover: *Self-Portrait* (major portion), c. 1875. Oil on canvas, 25¼ x 20¾ in. (64 x 53 cm). Musée d'Orsay, Paris.
Back cover: *Still Life with Apples and Oranges*, c. 1899. Oil on canvas, 29⅛ x 36⅝ in. (74 x 93 cm). Musée d'Orsay, Paris.
Spine: Detail of *Still Life with Plaster Cupid*, 1894–95. See page 82.
Frontispiece: Detail of *Mont Sainte-Victoire with Large Pine*, c. 1887. See page 197.
Page 6: Detail of *Still Life with Onions*, 1896–98. See page 84.
Page 16: Detail of *The Murder*, c. 1867–68. See page 37.
Page 58: Detail of *The Kitchen Table (Still Life with Basket)*, 1888–90. See page 73.
Page 96: Detail of *Portrait of Mme Cézanne*, 1888–90. See page 116.
Page 148: Detail of *L'Estaque: View of the Bay of Marseilles*, c. 1878–79. See page 167.
Page 244: Detail of *Four Bathers*, 1888–90. See page 259.

A note about the captions:
The dating of Cézanne's works, with some exceptions, is the subject of continuing scholarly debate. The dates given here are those generally agreed upon or those of recent publications.

For copyright and Cataloging-in-Publication Data, see page 287.

# CONTENTS

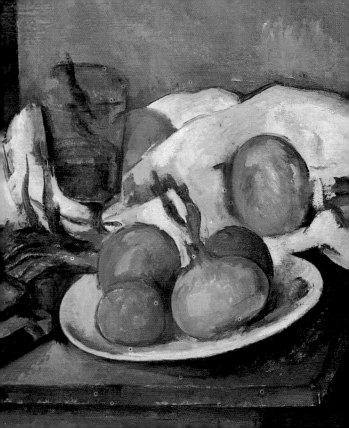

# INTRODUCTION
## "THE FATHER OF US ALL"

Throughout the history of Western culture, a handful of individuals have changed the way we perceive the world around us, even the way we think about ourselves. In the sciences, Galileo, Charles Darwin, Albert Einstein, perhaps Sigmund Freud, are the first names to come to mind; in art, Giotto and Paul Cézanne. Five hundred years of traditional Western painting, especially the illusionism that artists strove for from the fourteenth to the nineteenth centuries, were signaled by Giotto's robustly modeled figures.

Cézanne was the first to suggest how these deeply entrenched values could be transformed. His pictures powerfully evoke the physical reality of our surroundings, yet they do so not by replicating appearances but by creating independent structures built of color, with unprecedented emphasis on the material fact of paint on a flat surface. Forms in Cézanne's paintings don't seem to retreat into fictive space, as they do in traditional images; instead, they appear to thrust at the viewer. Yet for all the arresting newness of his art, Cézanne never rejected tradition. "To my mind," he wrote in 1905, "one should not substitute oneself for the past, one has merely to add a

new link." He achieved his aim. His work connects the past with what was to come, clearly pointing to what would be the future of adventurous painting but, at the same time, profoundly informed by the Classicism of Nicolas Poussin, the Romanticism of Eugène Delacroix, the Realism of Gustave Courbet, and much more. Two years before his death, at work on pictures that still appear innovative and challenging, Cézanne wrote to a younger artist that the greatest painters were "the Venetians and the Spaniards."

Much of the upheaval that we call modernism in Western painting has its origins in Cézanne's art. Until recently, Cézanne was the artist any ambitious painter had to come to terms with, if he was to discover his own identity. To Henri Matisse, he was "the father of us all," to Pablo Picasso, "a mother who protects her children," and to Paul Klee, "the teacher par excellence." Matisse and Picasso both owned, cherished, and learned from works by Cézanne.

Whole movements, entire reconceptions of what painting could be, are rooted in Cézanne's hard-won innovations. Fauvism's startling translation of perceived reality into structures of saturated color merely intensifies Cézanne's method of modeling with contrasting warm and cool hues; Cubism's radical reinvention of how painting could refer to space and form (the first real change since the fifteenth

century, when Giotto's ideas were codified as mathematical linear perspective) stems from Cézanne's way of setting those hues side by side, as discrete patches of paint. The unstable space of Cubism has its origin in the way Cézanne's forms seem to bulk toward us, in a reversal of traditional perspective—and so does the allover expansiveness typical of American postwar abstraction.

The confrontational flat expanses of Abstract Expressionism, Color Field abstraction, and Minimalism can be read as extreme manifestations of the insistent frontality and *presentness* of Cézanne's paintings; the material drama of these recent works simply heightens his affirmation of the expressive reality of both paint and flat canvas. It even is arguable that today's dominance of idea over form, a legacy of Marcel Duchamp's playful iconoclasm in the late teens and twenties, also owes something to Cézanne's stubborn independence of mind, his refusal, despite his well-documented desire for recognition and honor, to make his work conform to the standards of his day—even those of his fellow rebels.

Without Cézanne, the history of art from the mid-nineteenth century on might have been quite different, yet he seems an unlikely candidate for such a pivotal role. Severe, uningratiating, introspective, cerebral, his art seems driven by overwhelming personal necessities rather than by pictorial concepts with more general applications.

His subject matter is conventional; his innovations can seem inadvertent. Passionate in his desire to be truthful to his "sensations," he was wracked with anxiety about being equal to the task, calling himself "the primitive of the way I discovered." Only at the very end of his life, a month before his death, did he write: "I am continually making observations from nature, and I feel that I am making some slight progress."

Cézanne's biography is uneventful. Born in the provincial town of Aix-en-Provence in 1839, the son of a prosperous (and autocratic) hat manufacturer turned banker, he died there in 1906. As a young man, he studied law for a few years at the University of Aix, without enthusiasm, and wrote poetry—in the Romantic mode—but his passion was for art. Although he displayed no precocious talent, as early as 1857 he began to work at the Free Municipal School for Drawing in Aix, his principal art training until he finally obtained permission from his father, in 1861, to abandon his law studies and go to Paris.

There, enrolled at the Académie Suisse, Cézanne met Camille Pissarro, who was to have an important influence on his work, and later, other "new painters," as the Impressionists were then called. After six months he returned to Aix, in discouragement, to work in his father's bank. Yet he soon left the family enterprise and returned to Paris to devote himself entirely to painting—supported by a modest

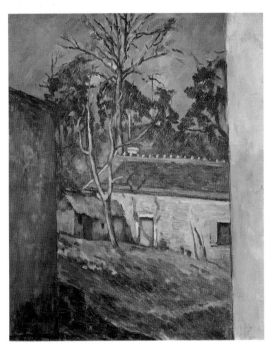

*Farm Courtyard in Auvers*, c. 1879–80.
Oil on canvas, 25½ x 21¼ in. (65 x 54 cm).
Musée d'Orsay, Paris.

allowance from his father. He spent most of the next few years in the capital, with brief returns to Aix, absorbing and expanding the ideas current among his adventurous contemporaries.

Cézanne also attempted and failed the entry examinations for the Ecole des Beaux-Arts. The most radical painter of his generation longed for official recognition, annually submitting work to the Salon and—except for one aberration in 1882—suffering annual rejections. The "new painters," however, welcomed him, and he joined them in 1874 in the celebrated "alternative" show now known as the first Impressionist exhibition. Cézanne continued to exhibit with the "new painters" for several years, even though he never shared their desire to homogenize forms in a sensuous haze of color, a distinction that the Cézanne scholar Lawrence Gowing has termed the difference between painters of effects and a painter of *things*. Cézanne kept in touch with his colleagues, especially Pissarro, but he became increasingly self-contained. Dividing his time principally between Paris and Aix and its environs, he slowly pursued his highly individual notion of re-creating on canvas his "sensations," as he called his intense awareness of the density and visual weight of the elements of his surroundings.

Cézanne had champions among his fellow artists, notably Pissarro, with whom he worked closely in the

early 1870s (to the benefit of both men's work); Edouard Manet, who praised Cézanne's still lifes; and Gustave Caillebotte, an *amateur* in the truest sense, who befriended the Impressionists, bought their work, painted alongside them, and later left his remarkable collection to the nation. Emile Zola, the acclaimed novelist and journalist who publicly defended the work of the Impressionists, had grown up with Cézanne in Aix and was one of his intimates until 1886, when the painter broke with his boyhood friend, deeply hurt by what he believed was an unflattering portrait of himself as the unstable, obsessed, and failed artist in Zola's novel, *L'Oeuvre (Masterpiece)*. Practical support came from Ambroise Vollard, who opened his legendary Paris gallery in 1894 with art acquired at the auction of the stock of Père Tanguy, a dealer in paints, brushes, canvas, and work by some of the most advanced artists of his day, which he obtained in exchange for supplies. (Tanguy was immortalized in two portraits by Vincent van Gogh, just as Vollard would be by the artists he represented, including Cézanne.)

Despite the evident authority of his work and his subsequent influence, during his lifetime Cézanne remained chiefly an "artist's artist." Not until his last decade did he begin to exhibit with some regularity in group exhibitions in Paris and, occasionally, outside France. (His 1895 solo exhibition at Vollard's new gallery was his first.) He was

well represented in the Salons d'Automne, Les Indépen-dants, and in a watercolor exhibition at Vollard's gallery, but most influential was the large retrospective organized after his death for the 1907 Salon d'Automne, an exhibition that can be said to have changed the course of modernism. (It also provoked the poet Rainer Maria Rilke's series of extraordinary letters on "the Cézanne inscape.")

The next generation of adventurous artists was fasci-nated by Cézanne. A twenty-year-old Georges Braque, newly arrived in Paris in 1902, was so struck by Caille-botte's Cézannes, installed at the Musée du Luxembourg after a long wrangle, that he sought out other works at Vollard's. That Cézanne's art offered Braque, Picasso, and Matisse a model of rigorous construction and visual weight that owed nothing to traditional illusionism is plainly visible in their work after 1907. It is plain, too, that for the rest of their lives, Cézanne's art remained the standard of excellence against which they measured their own achievements. Matisse, for example, was still paint-ing homages to Cézanne as a mature artist of nearly fifty, even after having created some of the most extraordinary work in the history of Western art.

Cézanne's art is full of contradictions. It is dispassion-ate and full of feeling, disciplined and intense, detached and deeply engaged, profoundly inventive and no less profoundly rooted in actual experience. His pictures seem

at once inevitable and willful, immutable and about to dissipate into isolated strokes. Cézanne's celebrated method of rendering form with juxtaposed patches of warm and cool color creates a wholly convincing sense of bulk and mass, but at the same time, his deliberate placement of those patches forcibly reminds us of the flatness of the canvas and the artifice of painting itself. His disjunctive touches, his slow accretion of carefully orchestrated tonalities, make us recapitulate his fierce scrutiny of the motif, so that the disembodied act of seeing becomes as physical and tangible as the repetitive pats of pigment. Cézanne's work vibrates with the tension between these contradictory notions, and it is this sense of unrest, of simultaneous instability and solidity that gives his pictures their continuing power to disturb and to exalt. It is part of what makes them modern.

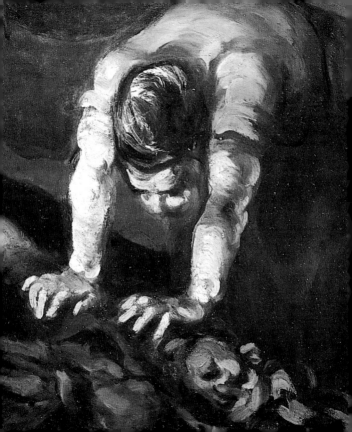

# EARLY WORK

Cézanne's youthful works are uncomfortable, super-heated. Even apparently neutral landscapes, still lifes, and portraits share the feverish intensity of the violent, erotic, and religious subjects and the obscure, lurid allegories of his early years—a body of work seemingly unlike the cool, slowly wrought paintings of his maturity. Only the ambiguous bathers that preoccupied Cézanne through-out his life seem related to his agitated biblical scenes and sensational bacchanals of the 1860s and early 1870s.

These formative works bear witness to Cézanne's struggle with his strengths and weaknesses, his battle with recalcitrant materials. Drawing is awkward; painting, whether in oil or watercolor, clogged. Whereas Cézanne's mature pictures evoke elemental forms with the most fragile means—muscular, quivering drawing and transient gatherings of transparent planes—his early works are labored illustrations of fraught dramas. Yet when pressed, the eager young painter could paint quite skillfully, espe-cially when copying works by artists he admired.

His heroes ranged from Delacroix—the quintessential Romantic and the inspiration for Cézanne's early choice of literary subjects, his lush palette, and his violent con-trasts of dark and light—to Courbet, the quintessential

Realist and the source of the young painter's tough, vigorous landscapes. Courbet offered a model, too, for a new way of being an artist. Equally renowned for the gritty intensity of his paintings and for his defiance of the establishment, and with a wholly modern understanding of publicity, Courbet thrived on controversy, submitting works to the Salon that were calculated to elicit outrage and organizing his own highly publicized independent exhibitions.

By the 1860s the Salon's traditional preference for large-scale narrative painting had begun to erode, to the consternation of a public trained to value pictures of heroic figures in action as superior to any others. Large-scale Realist landscapes, such as those by Camille Corot and the Barbizon painters, began to be taken as seriously as scenes from mythology, ancient history, or the Bible. They offered a stimulating example to a younger generation of painters, including Cézanne, who were interested in recording their observations truthfully. Courbet's landscapes were the most energetic, robust versions of this idiom, which was part of their appeal, but Cézanne also grasped the importance of Courbet's varied, apparently inconsistent paint application—something that nineteenth-century eyes often found disturbing—and made paint handling itself crucial to the expressive force of his own pictures.

This was first manifest in Cézanne's palette-knife pictures of the 1860s and '70s—nearly brutal portraits of family and friends rendered with slabs of thick, dragged paint. These are startling pictures whose sheer force of feeling nearly wrenches them off the wall, almost into another century. Since Cézanne destroyed many of his early works, we will never know precisely what he achieved during this formative period, but it is evident that the seeming left-handedness of such pictures was not due to ineptness. Like the apparent maladroitness of his bacchanals, it was the result of Cézanne's lifelong quest for an intensity that would trigger the same powerful feelings as his own "sensations" in the face of actuality—not through illusionism but through the character of paint itself.

The extravagance of Cézanne's early work is not surprising. The same pounding emotion is present, just below the surface, in even the driest of his mature paintings, detached from explicit reference, transformed into ferocious scrutiny, and disguised as scrupulous modulation of tones. The anarchy of the early paintings should make us admire all the more the intelligence that allowed Cézanne to channel his emotion and subordinate it to painterly considerations, to the enduring benefit of his art.

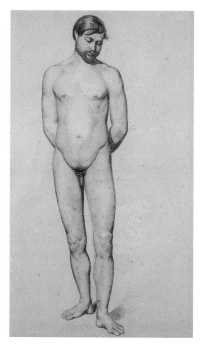

*Male Nude,* 1862.
Graphite on paper, 23⅝ x 15¼ in. (60 x 39 cm).
Musée Granet, Aix-en-Provence, France.

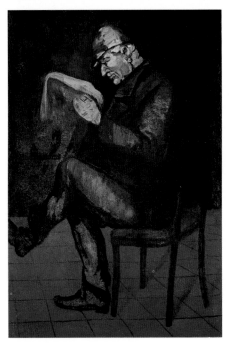

*Portrait of Louis-Auguste Cézanne, Father of the Artist,* c. 1862.
Oil on thin plaster on canvas, 66 x 45 in. (168 x 114 cm).
The National Gallery, London.

21

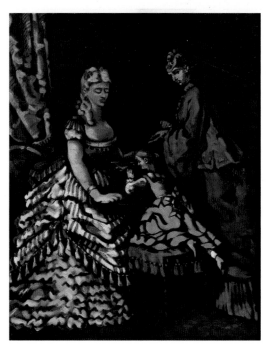

*Interior with Two Women and a Girl,* early 1860s.
Oil on canvas, 35¾ x 28¼ in. (91 x 72 cm).
Pushkin Museum of Fine Arts, Moscow.

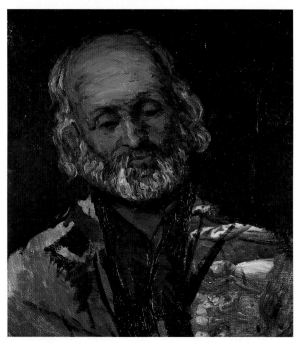

*Head of an Old Man*, c. 1865–67.
Oil on canvas, 20 x 18⅞ in. (51 x 48 cm).
Musée d'Orsay, Paris.

23

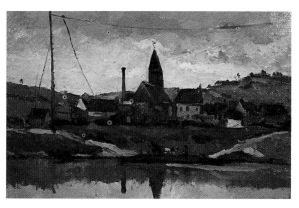

*View of Bonnières,* c. 1866.
Oil on canvas, 15 x 23⅝ in. (38 x 60 cm).
Musée du Docteur Faure, Aix-les-Bains, France.

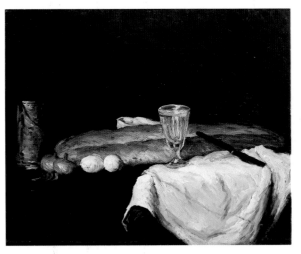

*Still Life: Bread and Eggs,* 1865.
Oil on canvas, 23¼ x 29⅞ in. (59 x 76 cm).
Cincinnati Art Museum.

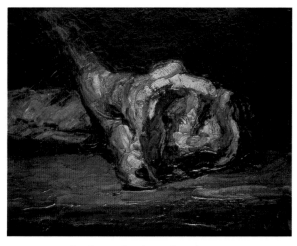

*Still Life: Bread and Leg of Lamb,* c. 1866.
Oil on canvas, 10¾ x 13¾ in. (27 x 35 cm).
Kunsthaus Zurich.

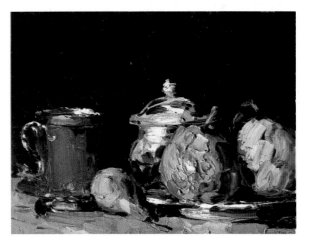

*Sugar Bowl, Pears, and Blue Cup*, c. 1866.
Oil on canvas, 11¾ x 16 in. (30 x 41 cm).
Musée Granet, Aix-en-Provence, France.

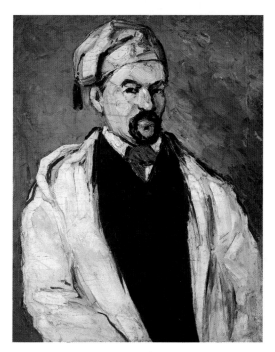

*Dominique Aubert (Uncle Dominic),* 1866.
Oil on canvas, 31⅜ x 25¼ in. (79.7 x 64.1 cm).
The Metropolitan Museum of Art, New York.

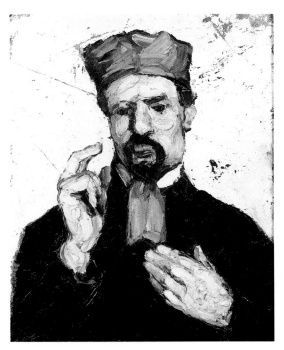

*The Lawyer (Uncle Dominique)*, c. 1866.
Oil on canvas, 24¼ x 20½ in. (62 x 52 cm).
Musée d'Orsay, Paris.

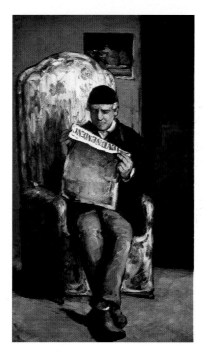

*The Artist's Father*, 1866.
Oil on canvas, 78¼ x 47 in. (198.5 x 119.3 cm).
National Gallery of Art, Washington, D.C.

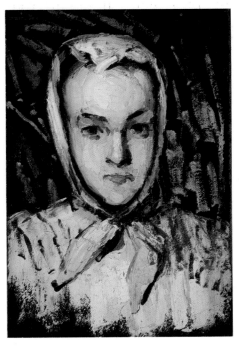

*Portrait of Marie Cézanne, Sister of the Artist,* c. 1866–67.
Oil on canvas, 21 x 13½ in. (53.5 x 37 cm).
The Saint Louis Art Museum.

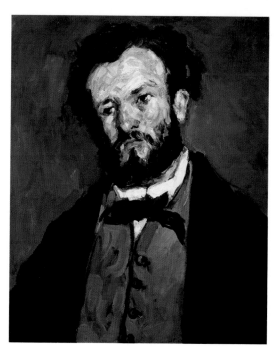

*Portrait of Antony Valabrègue*, c. 1866.
Oil on canvas, 23⅝ x 19¾ in. (60 x 50 cm).
The J. Paul Getty Museum, Malibu, California.

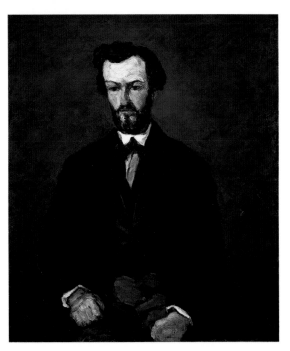

*Portrait of Antony Valabrègue,* 1866.
Oil on canvas, 45¾ x 38¾ in. (116.3 x 98.4 cm).
National Gallery of Art, Washington, D.C.

33

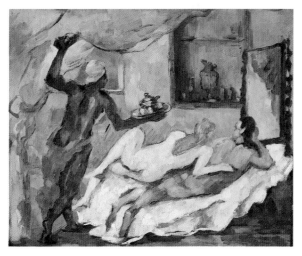

*Afternoon in Naples,* c. 1875.
Oil on canvas, 17⅝ x 32⅞ in. (45 x 83.6 cm).
Australian National Gallery, Canberra.

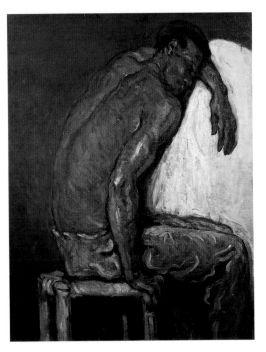

*The Negro Scipion,* c. 1867.
Oil on canvas, 42⅛ x 32⅝ in. (107 x 83 cm). Museu de Arte
de São Paulo Assis Chateaubriand, São Paulo, Brazil.

35

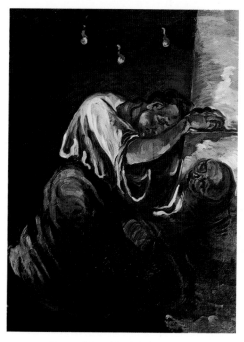

*Sorrow (Mary Magdalen)*, c. 1867.
Oil on canvas, 65 x 48¾ in. (165 x 124 cm).
Musée d'Orsay, Paris.

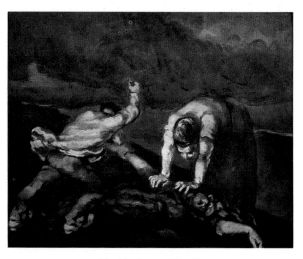

*The Murder,* c. 1867–68.
Oil on canvas, 25¾ x 31½ in. (64 x 81 cm).
National Museums and Galleries on Merseyside,
Walker Art Gallery, Liverpool, England.

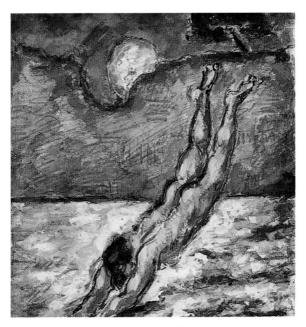

*Woman Diving into the Water*, 1867–70.
Graphite, watercolor, and gouache on paper, 5 x 4⅝ in. (12.7
x 12.1 cm). National Museum and Gallery of Wales, Cardiff.

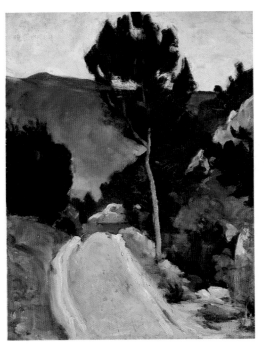

*Roadway in Provence*, c. 1868.
Oil on canvas, 35⅞ x 28 in. (92.4 x 72.5 cm).
Musée des Beaux-Arts, Montreal.

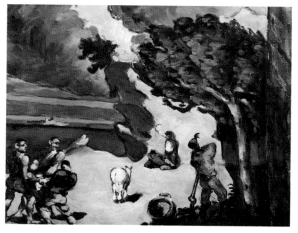

*The Robbers and the Ass,* c. 1869–70.
Oil on canvas, 16 x 21¾ in. (41 x 55 cm).
Galleria d'Arte Moderna, Milan.

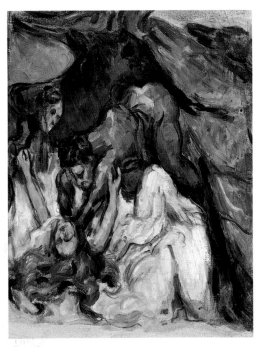

*The Strangled Woman,* c. 1870–72.
Oil on canvas, 12 x 9¾ in. (31 x 25 cm).
Musée d'Orsay, Paris.

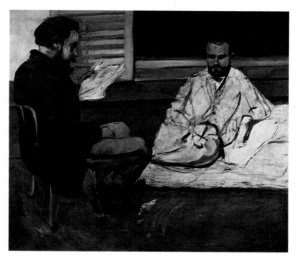

*Paul Alexis Reading to Emile Zola*, c. 1869–70.
Oil on canvas, 51⅛ x 63 in. (130 x 160 cm). Museu de Arte
de São Paulo Assis Chateaubriand, São Paulo, Brazil.

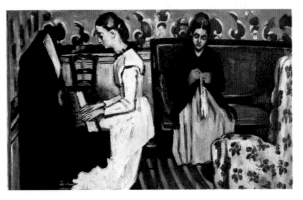

*Young Woman at the Piano—Overture to "Tannhäuser,"*
c. 1869–70. Oil on canvas, 22½ x 36¼ in. (57 x 92 cm).
Hermitage Museum, Saint Petersburg.

43

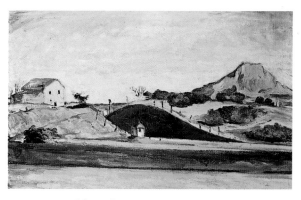

*The Railway Cutting,* c. 1869–70.
Oil on canvas, 31½ x 50¾ in. (80 x 129 cm).
Bayerische Staatsgemäldesammlungen, Munich.

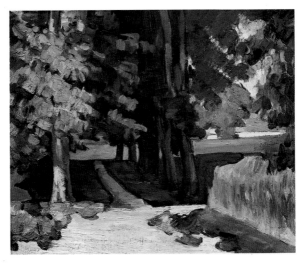

*Avenue of Chestnuts, Jas de Bouffan,* c. 1871.
Oil on canvas, 14½ x 17¼ in. (37 x 44 cm).
The Tate Gallery, London.

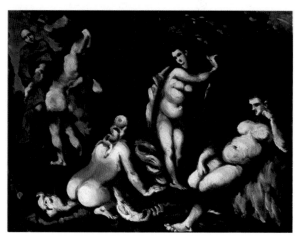

*The Temptation of Saint Anthony,* c. 1870.
Oil on canvas, 22¼ x 29¾ in. (54 x 73 cm).
Foundation E. G. Bührle Collection, Zurich.

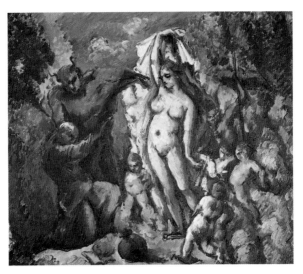

*The Temptation of Saint Anthony*, c. 1874–75.
Oil on canvas, 18½ x 22 in. (47 x 56 cm).
Musée d'Orsay, Paris.

*Portrait of Delacroix,* c. 1870–71.
Chalk on paper, 5⅝ x 5¼ in. (14 x 13 cm).
Musée Calvet, Avignon, France.

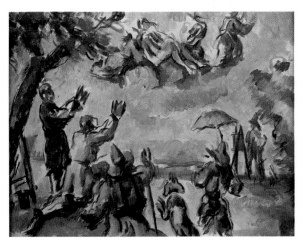

*Apotheosis of Delacroix*, c. 1870.
Oil on canvas, 10½ x 13¾ in. (27 x 35 cm).
Musée d'Orsay, Paris.

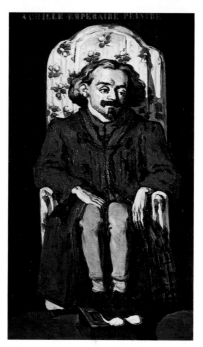

*Portrait of the Painter Achille Emperaire*, c. 1869–70.
Oil on canvas, 78¾ x 48 in. (200 x 122 cm).
Musée d'Orsay, Paris.

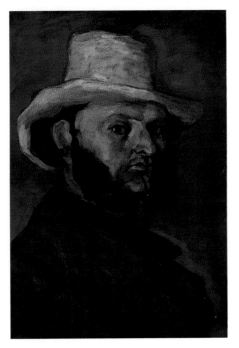

*The Man with a Straw Hat: Gustave Boyer*, c. 1871.
Oil on canvas, 21⅝ x 15¼ in. (54.9 x 38.7 cm).
The Metropolitan Museum of Art, New York.

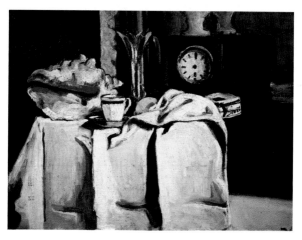

*The Black Marble Clock,* c. 1869–70.
Oil on canvas, 21¾ x 29¼ in. (55.2 x 74.3 cm).
Private collection.

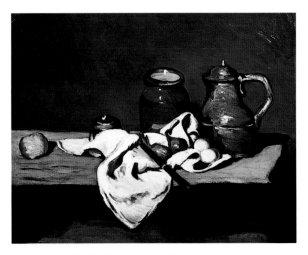

*Still Life: Green Pot and Pewter Jug,* c. 1870.
Oil on canvas, 24¾ x 31½ in. (63 x 80 cm).
Musée d'Orsay, Paris.

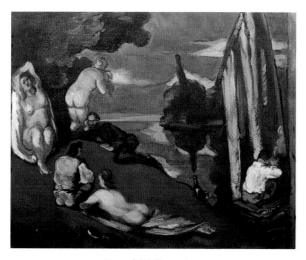

*Pastoral (Idyll)*, c. 1870.
Oil on canvas, 25¾ x 31¾ in. (65 x 81 cm).
Musée d'Orsay, Paris.

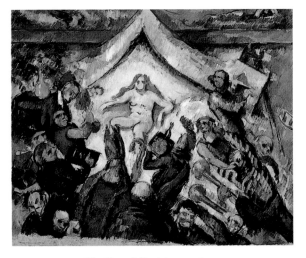

*The Eternal Feminine,* c. 1877.
Oil on canvas, 17 x 20⅞ in. (43.2 x 53.3 cm).
The J. Paul Getty Museum, Malibu, California.

*Olympia,* c. 1877.
Graphite and watercolor on paper, 9¾ x 11¼ in.
(25.5 x 27.5 cm). Philadelphia Museum of Art.

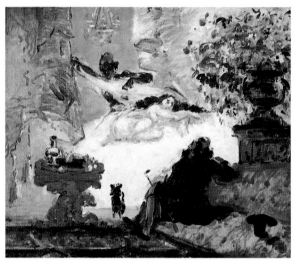

*A Modern Olympia*, c. 1873–74.
Oil on canvas, 18½ x 21⅝ in. (46 x 55 cm).
Musée d'Orsay, Paris.

# STILL LIFES

At first sight, Cézanne's still lifes seem to be modest, intimate views of the ordinary accoutrements of middle-class life: a compote, a flowered pitcher, a blue vase, a carafe, all set against patterned wallpaper and figured cloth. Cézanne was attached to his objects and apparently comforted by them, carrying them from Aix to Paris whenever he shuttled between the two locations (this has compounded the difficulties of dating the paintings made in these years). Their familiarity liberated him and allowed him to concentrate on larger pictorial issues, so that the apparently unassuming pictures that he based on these objects are, in fact, among the most monumental and complex in the history of modernism. Their space expands and contracts; forms strain toward us as though striving to reveal every aspect of their being. A spill of fruit across a crumpled cloth becomes a metaphorical landscape; crockery becomes architecture, onions and apples become geologic forms, and a ruck of fabric, a surrogate mountain. In a celebrated essay the art historian Meyer Schapiro has suggested, persuasively, that for the notoriously timid Cézanne the apples of his still lifes were equivalents for the breasts of the nudes in his early bacchanals.

What concerned Cézanne was clearly not the anecdotal history of his objects but the essential character of their forms. "Treat nature by the cylinder, the sphere, and the cone," he advised his young painter friend Emile Bernard. (Cézanne's letters to Bernard, written from 1904 until a month before the older artist's death, are our sole source of what might be called his theory.) This was not a directive to reduce everything to a neutral geometry, but rather a plea for the spirit that informs the best Greek sculpture—the sense that a pure geometric archetype has miraculously been brought to life. Cézanne's desire for a seamless coexistence of ideal form with the specifics of observed actuality explains his passion for Poussin, who was at once the author of some of the most austere, rational paintings in the history of French art and a keen observer of the sensory world, who, like Cézanne himself, revered the Venetian painters of the Renaissance.

Cézanne's still lifes include many of his best-known paintings and some of his most prescient, such as the astonishing *Still Life with Plaster Cupid* (page 83). The subject is one that a student at the Ecole des Beaux-Arts might have encountered: a cast of a sculpture attributed variously to François du Quesnoy or Pierre Puget. But the painting is compellingly irrational. Cézanne frequently played with ambiguity in his still lifes, setting bouquets of flowers and bowls of fruit against patterned

cloths and busy wallpapers, but *Still Life with Plaster Cupid* goes beyond the ambiguous into the disorienting. A painted image of a replica of a sculpture resonates against a painting of a painting—of a cast of a sculpture by Michelangelo. We are uncertain what is where, even what is what. The relation of foreground objects to the stacked canvases of the background (perhaps an homage to Poussin's famous self-portrait in the Louvre) eludes logic. Scale shifts. Distinctions blur between the two- and the three-dimensional, and between the real and the fictive. The tabletop, as in so many of Cézanne's still lifes, seems to tip forward, while the forms of the sculpture alternately loom at us and slip away; background space warps and fragments, as though responding to the articulations of the Cupid that dominates the foreground.

These intensely serious visual games force us to meditate on the nature of painting itself, on the enigmatic enterprise of making two-dimensional images that ostensibly correspond to our experience of a three-dimensional world. The subject of the picture ceases to be the gathering of household objects and studio props that we recognize as part of Cézanne's habitual vocabulary and becomes, instead, the act of seeing and, by extension, the notion of perception itself.

*Still Life with Philippe Solari Medallion: Cézanne's Accessories,*
c. 1873. Oil on cardboard on canvas, 23⅝ x 31¾ in.
(60 x 81 cm). Musée d'Orsay, Paris.

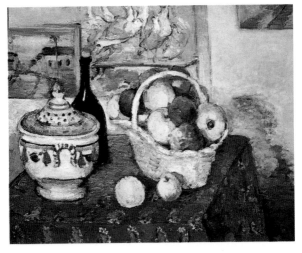

*Still Life with Soup Tureen*, c. 1873–74.
Oil on canvas, 25¾ x 32⅝ in. (65 x 83 cm).
Musée d'Orsay, Paris.

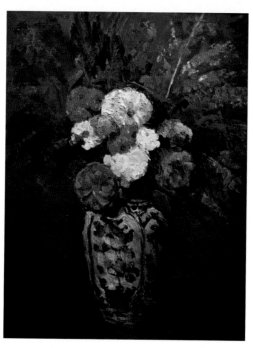

*Dahlias (Dahlias in a Delft Vase),* 1873–75.
Oil on canvas, 28¾ x 21¼ in. (73 x 54 cm).
Musée d'Orsay, Paris.

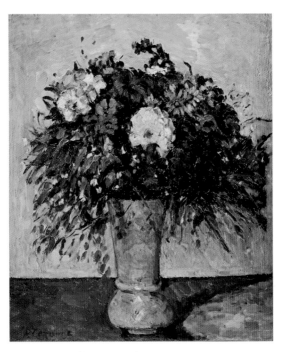

*Flowers in a Blue Vase,* 1874–75.
Oil on canvas, 21⅝ x 18⅛ in. (55 x 46 cm).
Hermitage Museum, Saint Petersburg.

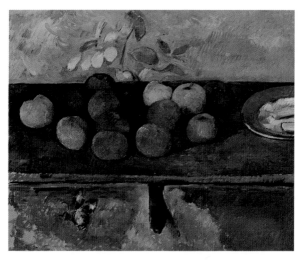

*Apples and Biscuits,* c. 1880.
Oil on canvas, 18⅛ x 21½ in. (46 x 55 cm).
Musée de l'Orangerie, Paris.

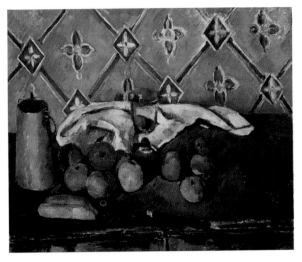

*Fruit, Napkin, and Milk Pitcher*, c. 1879–82.
Oil on canvas, 23½ x 28¾ in. (60 x 73 cm).
Musée de l'Orangerie, Paris.

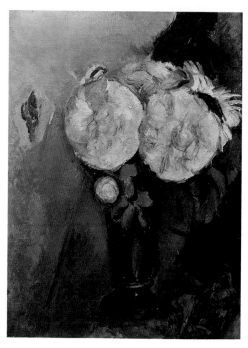

*Flowers in a Blue Vase,* c. 1880.
Oil on canvas, 11⅞ x 9 in. (30 x 23 cm).
Musée de l'Orangerie, Paris.

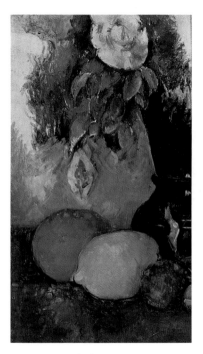

*Fruit and Flowers,* 1882–86.
Oil on canvas, 13¾ x 8¼ in. (35 x 21 cm).
Musée de l'Orangerie, Paris.

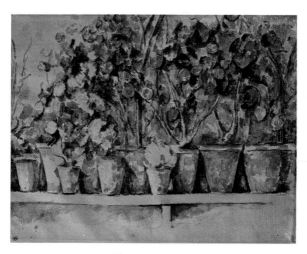

*Flowerpots,* c. 1885.
Pencil, graphite, and watercolor on paper, 9¼ x 12⅛ in.
(23.6 x 30.8 cm). Musée du Louvre, Paris.

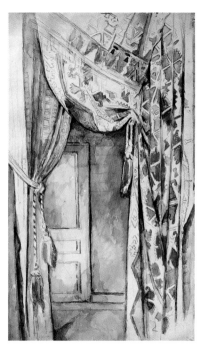

*The Curtains,* c. 1885.
Pencil, watercolor, and gouache on paper, 19⅜ x 12 in.
(49.1 x 30.5 cm). Musée du Louvre, Paris.

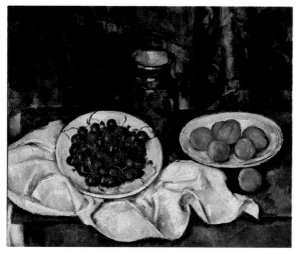

*Still Life with a Plate of Cherries,* 1885–87.
Oil on canvas, 19¾ x 24 in. (50.2 x 61 cm).
Los Angeles County Museum of Art.

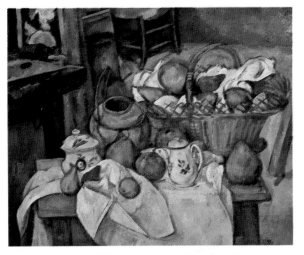

*The Kitchen Table (Still Life with Basket)*, 1888–90.
Oil on canvas, 25½ x 31½ in. (65 x 80 cm).
Musée d'Orsay, Paris.

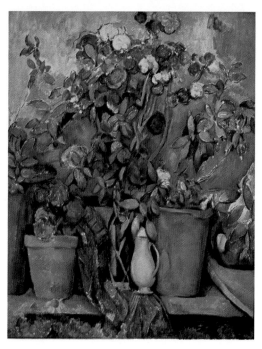

*Potted Plants (Geraniums),* 1888–90.
Oil on canvas, 36¼ x 28¼ in. (92 x 73 cm).
The Barnes Foundation, Merion, Pennsylvania.

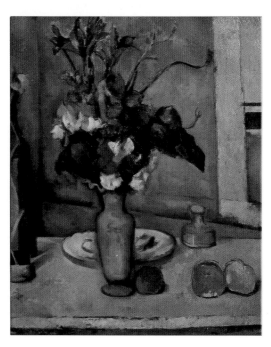

*The Blue Vase,* c. 1889–90.
Oil on canvas, 24½ x 20 in. (62 x 51 cm).
Musée d'Orsay, Paris.

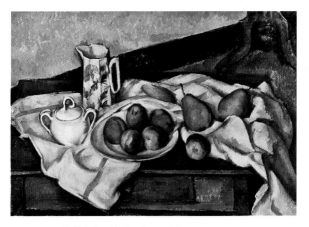

*Still Life with Peaches and Pears,* 1888–90.
Oil on canvas, 24 x 35⅜ in. (61 x 90 cm).
Pushkin Museum of Fine Arts, Moscow.

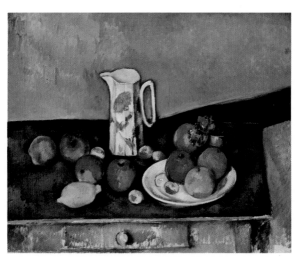

*Still Life with Milk Jug and Fruit,* c. 1890.
Oil on canvas, 29⅞ x 38¼ in. (75.9 x 97.2 cm).
Nasjonalgalleriet, Oslo.

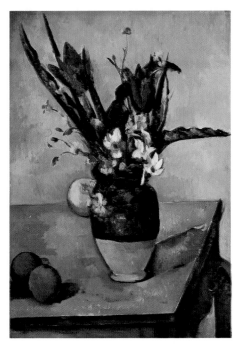

*Vase of Tulips*, 1890–92.
Oil on canvas, 23½ x 16½ in. (59.6 x 42.3 cm).
The Art Institute of Chicago.

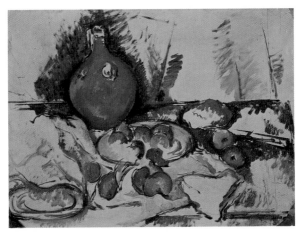

*Still Life with Water Jug,* c. 1893.
Oil on canvas, 20⅛ x 26¾ in. (51 x 68 cm).
The Tate Gallery, London.

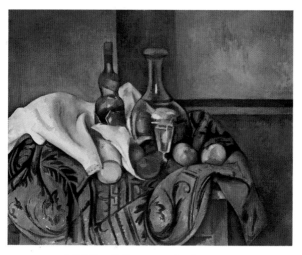

*Still Life with Peppermint Bottle,* c. 1894.
Oil on canvas, 26 x 32⅜ in. (65.5 x 82.1 cm).
National Gallery of Art, Washington, D.C.

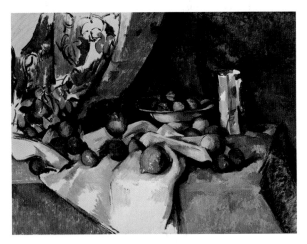

*Still Life with Apples,* 1895–98.
Oil on canvas, 27 x 36½ in. (68.6 x 92.7 cm).
The Museum of Modern Art, New York.

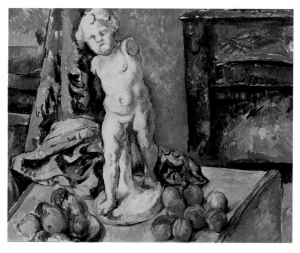

*Still Life with Plaster Cupid,* 1894–95.
Oil on canvas, 24¾ x 31¾ in. (63 x 81 cm).
Nationalmuseum, Stockholm.

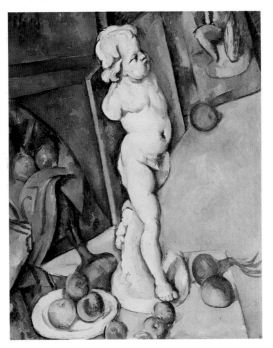

*Still Life with Plaster Cupid*, c. 1895.
Oil on paper mounted on panel, 27½ x 22½ in. (70 x 57 cm).
Courtauld Institute Galleries, London.

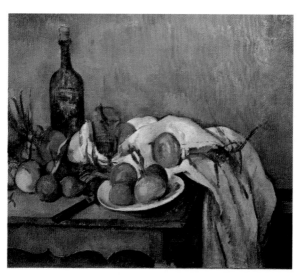

*Still Life with Onions,* 1896–98.
Oil on canvas, 26 x 32⅜ in. (66 x 82 cm).
Musée d'Orsay, Paris.

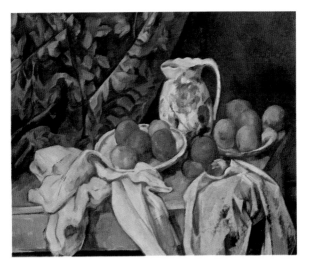

*Still Life with Curtain and Flowered Pitcher*, c. 1899.
Oil on canvas, 21½ x 29 in. (54.7 x 74 cm).
Hermitage Museum, Saint Petersburg.

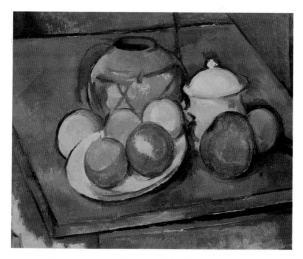

*Ginger Jar, Sugar Bowl, and Apples,* 1895–1900.
Oil on canvas, 14¼ x 18¼ in. (36 x 46 cm).
Musée de l'Orangerie, Paris.

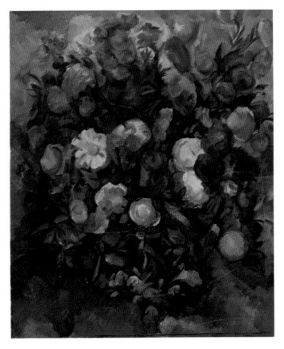

*Flowers (Copy after Delacroix's "Roses and Hydrangeas")*, 1902–4.
Oil on canvas, 30¼ x 23⅝ in. (77 x 64 cm).
Pushkin Museum of Fine Arts, Moscow.

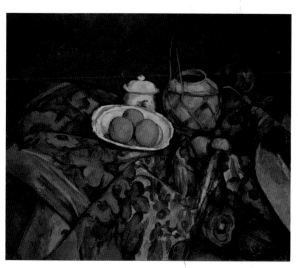

*Still Life with Ginger Jar, Sugar Bowl, and Oranges*, 1902–6.
Oil on canvas, 23⅞ x 28⅞ in. (60.6 x 73.3 cm).
The Museum of Modern Art, New York.

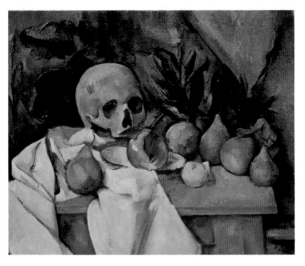

*Still Life with Skull,* 1896–98.
Oil on canvas, 21⅜ x 25⅝ in. (54.3 x 65 cm).
The Barnes Foundation, Merion, Pennsylvania.

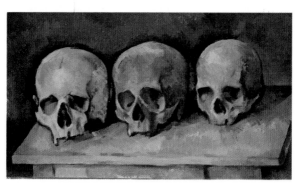

*Three Skulls,* 1898–1900.
Oil on canvas, 13⅜ x 25⅝ in. (34 x 60 cm).
The Detroit Institute of Arts.

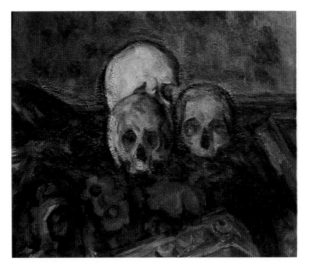

*Three Skulls on an Oriental Carpet,* 1898–1905.
Oil on canvas, 21¼ x 25½ in. (54 x 65 cm). Kunstmuseum,
Fondation Dübi-Müller, Solothurn, Switzerland.

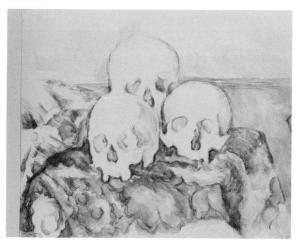

*Three Skulls,* 1902–6.
Watercolor, graphite, and gouache on paper, 18¾ x 24¾ in.
(48 x 62.8 cm). The Art Institute of Chicago.

*Plaster Cupid*, 1900–1904.
Graphite on paper, 18½ x 8⅝ in. (47 x 22 cm).
The Pierpont Morgan Library, New York.

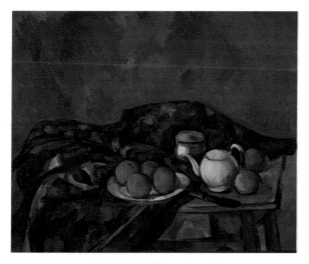

*Still Life with Teapot*, 1902–6.
Oil on canvas, 23 x 28½ in. (58.4 x 72.4 cm).
National Museum and Gallery of Wales, Cardiff.

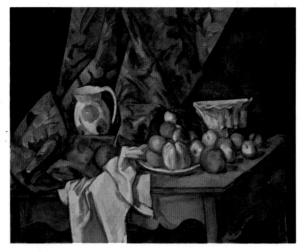

*Still Life with Flower Holder (Still Life with Apples and Peaches),*
c. 1905. Oil on canvas, 31⅞ x 39⅝ in. (81 x 100.5 cm).
National Gallery of Art, Washington, D.C.

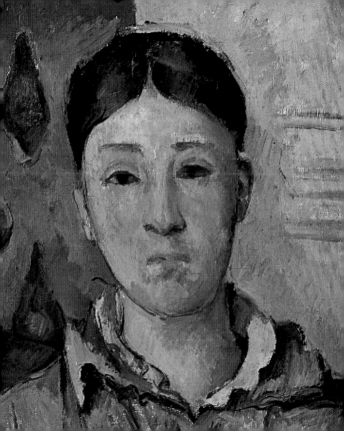

# PORTRAITS

Cézanne was notoriously demanding of anyone who consented to sit for him, expecting his models to behave like still-life objects. When he painted a portrait of Vollard, in 1899 (now in the Musée du Petit Palais, Paris), the dealer recounted that he was perched in a chair balanced precariously on a crate, not only forbidden to move but enjoined not even to speak, day after day, from eight in the morning until eleven thirty, with very brief rest periods. (Cézanne's method had obviously changed from when he painted a half-dozen palette-knife portraits of his Uncle Dominique at the rate of one a day.) After 115 sittings—ended only because Cézanne returned to Aix—the painter told Vollard, "I am not displeased with the shirtfront."

This frequently quoted remark should not be taken too literally, but it does suggest the rigor of Cézanne's approach. It suggests, too, the deep-seated anxiety that reverberates through his pictures, coexisting with but not eclipsing their intelligence and authority, an anxiety that prompted the philosopher Maurice Merleau-Ponty to title an incisive essay "Cézanne's Doubt." This anxiety makes itself visible in the hesitant edges of Cézanne's drawing, in the multiple, quavering strokes

that he substituted for the decisive contours of academic rendering. There are arguably no hard edges in nature, no clear boundaries to forms whose surface relations are infinitely variable to the eye of the beholder, but Cézanne apparently refused the possibility of even an abstract notion of boundary.

The artist's anxiety is palpable, too, in the wracked, elongated forms of both his still-life objects and his figures and in the tipped, unstable spaces they inhabit. These expressive "distortions" reflect the single-mindedness of the artist's gaze as he studied each plane of each element. The anxiety is also palpable in the elusive order of Cézanne's compositions, which resist notions of symmetry or geometric balance but instead unfold as wholly intuitive, slowly "realized"—his word—accumulations of narrowly focused, multiple perceptions.

What we know of Cézanne suggests that he was ill at ease with people, especially with women, suspicious that anyone who tried to get close to him wanted "to get his hooks in," so it is not surprising that he should wish his sitters to be as neutral and immobile as his still lifes. Paradoxically, his figure paintings seem at once detached and penetrating. The disquieting quality of some of the portraits, like their sense of introspection, may be due to the constraints that Cézanne imposed on his sitters or it may be an echo of the painter's "doubt," of his own discomfort.

This speculation is borne out by the fact that the portraits of the artist's son and of Hortense Fiquet, who became Mme Cézanne, are often relatively relaxed and tender, while Cézanne's self-portraits are often particularly animated and charged. It is worth noting, too, that when his subjects were completely absorbed, when their attention was as focused as his own, as in the marvelous series of card players, Cézanne achieved some of his most powerful paintings. Perhaps this is because he was able to ignore the threatening presence of the other and concentrate on pictorial issues: the dynamic paths of his sitters' limbs, the assonant rhyme of hat and bottle, the tension between the inward-angled poses of the seated men and the expanse of the canvas.

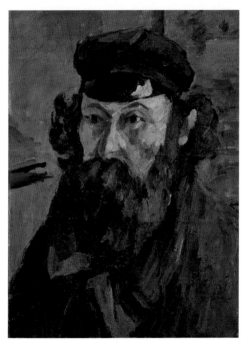

*Self-Portrait in a Cap,* 1873–75.
Oil on canvas, 21⅝ x 14⅞ in. (55 x 38 cm).
Hermitage Museum, Saint Petersburg.

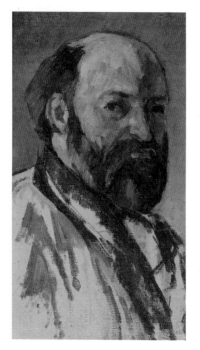

*Self-Portrait,* c. 1877.
Oil on canvas, 24 x 18¼ in. (61 x 46 cm).
The Phillips Collection, Washington, D.C.

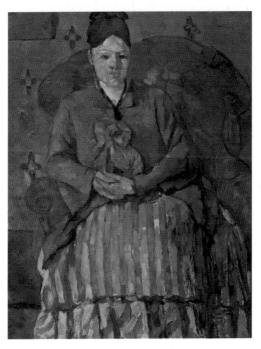

*Mme Cézanne in a Red Armchair,* 1877.
Oil on canvas, 28½ x 22 in. (72.5 x 56 cm).
Museum of Fine Arts, Boston.

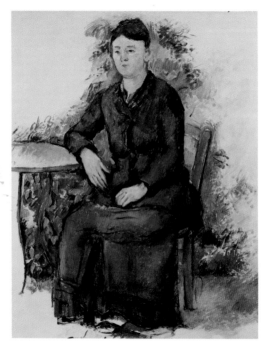

*Mme Cézanne in the Garden*, 1879–82.
Oil on canvas, 31½ x 24¾ in. (80 x 63 cm).
Musée de l'Orangerie, Paris.

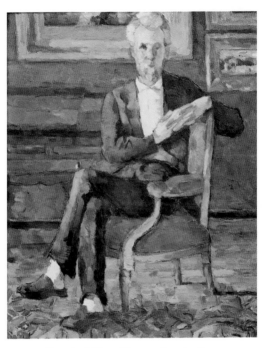

*Portrait of Victor Chocquet Seated,* 1877.
Oil on canvas, 17⅞ x 15 in. (45.7 x 38.1 cm).
Columbus Museum of Art, Columbus, Ohio.

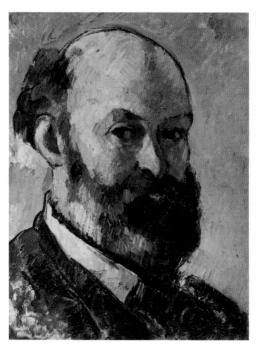

*Self-Portrait,* 1879–82.
Oil on canvas, 13¼ x 10½ in. (34 x 27 cm).
Oskar Reinhardt Collection, Winterthur, Switzerland.

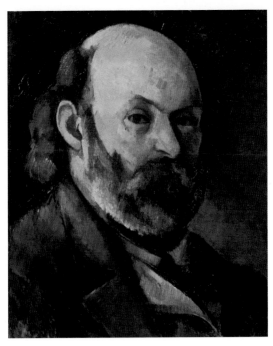

*Self-Portrait,* 1879–85.
Oil on canvas, 18¼ x 14¾ in. (46 x 38 cm).
Pushkin Museum of Fine Arts, Moscow.

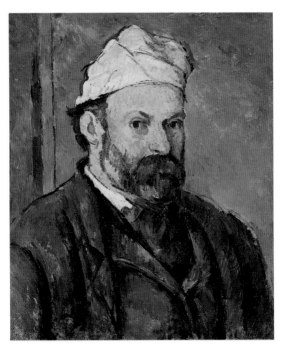

*Self-Portrait in a White Bonnet*, 1881–82.
Oil on canvas, 21¾ x 18¼ in. (55.4 x 46 cm).
Bayerische Staatsgemäldesammlungen, Munich.

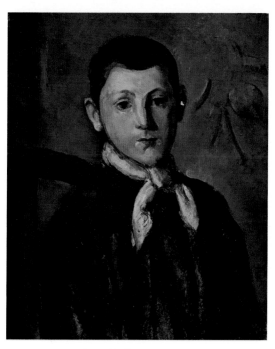

*Louis Guillaume,* c. 1882.
Oil on canvas, 22 x 18⅜ in. (55.9 x 46.7 cm).
National Gallery of Art, Washington, D.C.

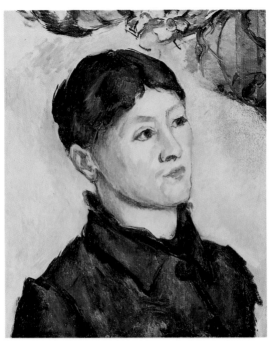

*Portrait of Mme Cézanne,* 1885–87.
Oil on canvas, 18⅛ x 15¹/₁₆ in. (46.3 x 38.3 cm).
Philadelphia Museum of Art.

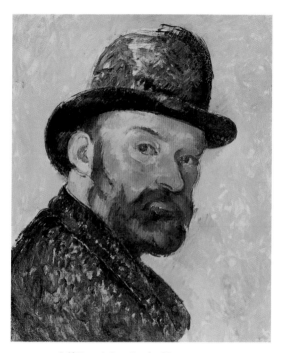

*Self-Portrait in a Bowler Hat*, 1883–87.
Oil on canvas, 17½ x 13⅞ in. (44.5 x 35.5 cm).
Ny Carlsberg Glyptotek, Copenhagen.

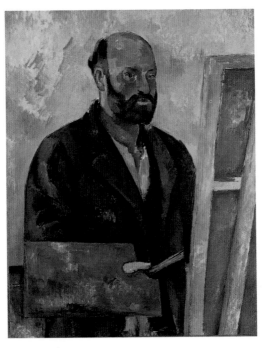

*Self-Portrait with a Palette,* 1885–87.
Oil on canvas, 36¼ x 28⅞ in. (92 x 73 cm).
Foundation E. G. Bührle Collection, Zurich.

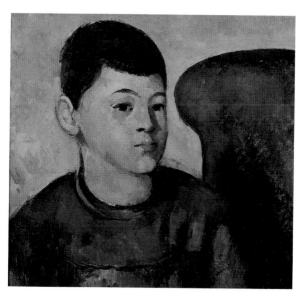

*Portrait of Paul Cézanne, Son of the Artist*, 1883–85.
Oil on canvas, 13¾ x 15 in. (35 x 38 cm).
Musée de l'Orangerie, Paris.

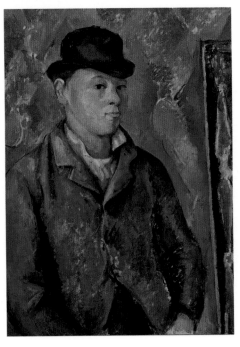

*The Artist's Son, Paul*, 1885–90.
Oil on linen, 25¾ x 21¼ in. (65.3 x 54 cm).
National Gallery of Art, Washington, D.C.

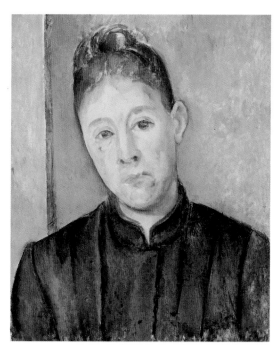

*Portrait of Mme Cézanne,* 1885–87.
Oil on canvas, 18⅛ x 14¾ in. (46 x 38 cm).
Musée Granet, Aix-en-Provence, France.

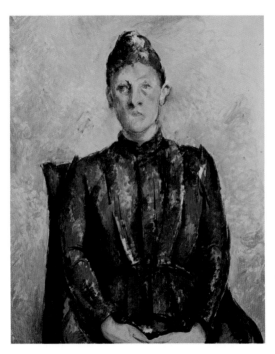

*Portrait of Mme Cézanne,* c. 1886–90.
Oil on canvas, 31¾ x 25½ in. (81 x 65 cm).
Musée de l'Orangerie, Paris.

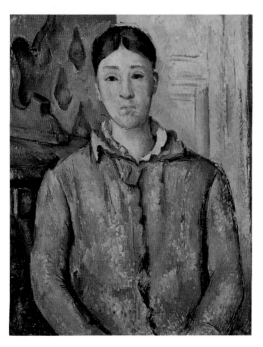

*Portrait of Mme Cézanne,* 1888–90.
Oil on canvas, 29 x 24 in. (73.5 x 61 cm).
The Museum of Fine Arts, Houston.

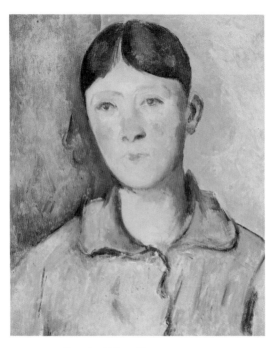

*Portrait of Mme Cézanne,* 1888–90.
Oil on canvas, 18½ x 15¼ in. (47 x 39 cm).
Musée d'Orsay, Paris.

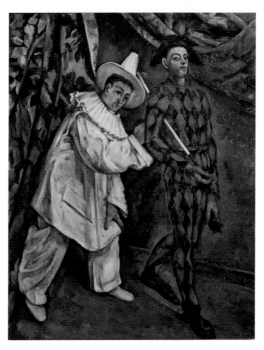

*Mardi Gras (Pierrot and Harlequin)*, 1888.
Oil on canvas, 39 x 31⅞ in. (100 x 81 cm).
Pushkin Museum of Fine Arts, Moscow.

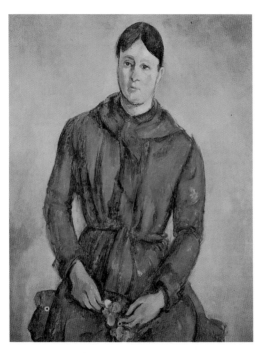

*Mme Cézanne in a Red Dress,* c. 1890.
Oil on canvas, 35½ x 27¾ in. (90 x 71 cm). Museu de Arte
de São Paulo Assis Chateaubriand, São Paulo, Brazil.

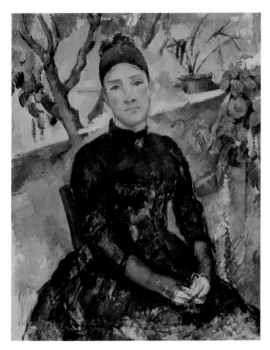

*Mme Cézanne in the Conservatory,* c. 1890.
Oil on canvas, 36¼ x 28¾ in. (92 x 73 cm).
The Metropolitan Museum of Art, New York.

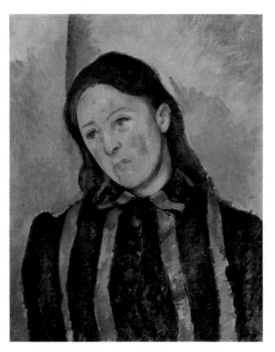

*Mme Cézanne in a Striped Blouse,* 1890–92.
Oil on canvas, 34⅜ x 20⅛ in. (62 x 51 cm).
Philadelphia Museum of Art.

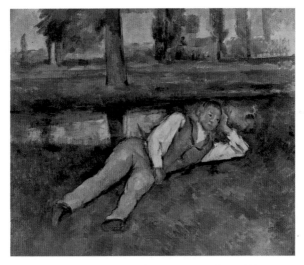

*Boy Resting,* c. 1890. Oil on canvas, 21¼ x 25¾ in.
(54.5 x 65.5 cm). Armand Hammer Museum of Art
and Cultural Center, U.C.L.A., Los Angeles.

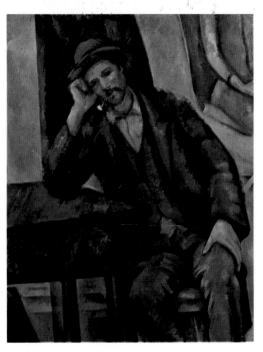

*The Smoker,* c. 1890–92.
Oil on canvas, 36½ x 29 in. (92.5 x 73.5 cm).
Pushkin Museum of Fine Arts, Moscow.

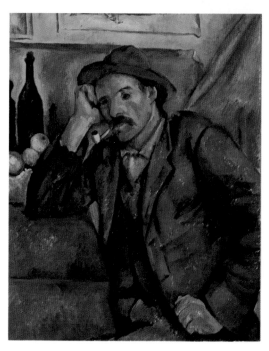

*The Smoker*, c. 1890–92.
Oil on canvas, 36½ x 29 in. (92.5 x 73.5 cm).
Hermitage Museum, Saint Petersburg.

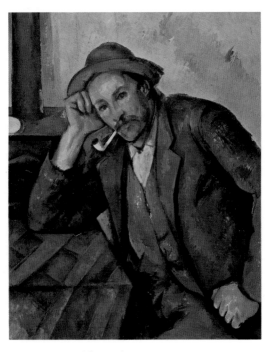

*The Smoker,* c. 1890–92.
Oil on canvas, 36½ x 29 in. (92.5 x 73.5 cm).
Städtische Kunsthalle Mannheim, Mannheim, Germany.

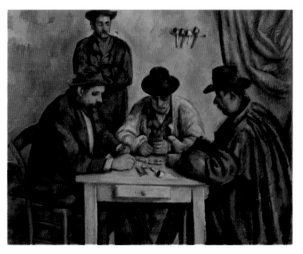

*The Card Players,* 1890–92.
Oil on canvas, 25¾ x 32¼ in. (65.4 x 81.9 cm).
The Metropolitan Museum of Art, New York.

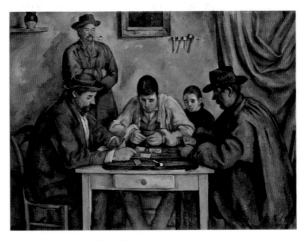

*The Card Players,* 1890–92.
Oil on canvas, 52¾ x 71½ in. (134 x 181.5 cm).
The Barnes Foundation, Merion, Pennsylvania.

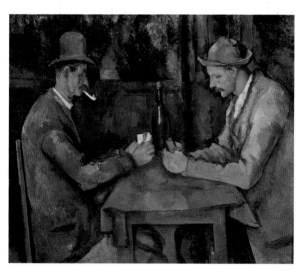

*The Card Players,* 1893–96.
Oil on canvas, 18½ x 22 in. (47 x 56 cm).
Musée d'Orsay, Paris.

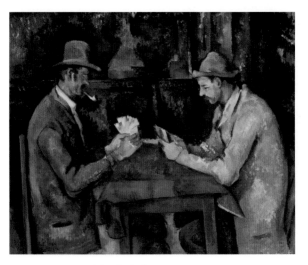

*The Card Players*, 1893–96.
Oil on canvas, 22⅞ x 27⅛ in. (58 x 69 cm).
Courtauld Institute Galleries, London.

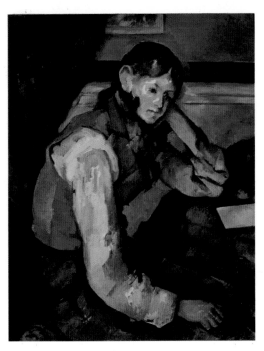

*Boy in a Red Waistcoat*, 1890–95.
Oil on canvas, 31¼ x 25⅛ in. (79.5 x 64 cm).
Foundation E. G. Bührle Collection, Zurich.

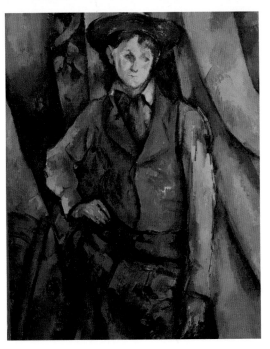

*Boy in a Red Waistcoat*, 1888–90.
Oil on canvas, 35¼ x 28½ in. (85.9 x 72.4 cm).
National Gallery of Art, Washington, D.C.

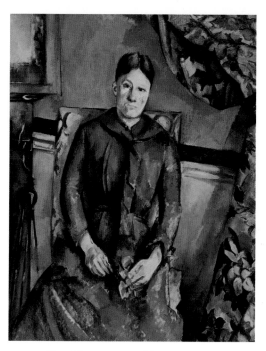

*Mme Cézanne in a Red Dress,* 1893–95.
Oil on canvas, 45⅞ x 35¼ in. (116.5 x 89.5 cm).
The Metropolitan Museum of Art, New York.

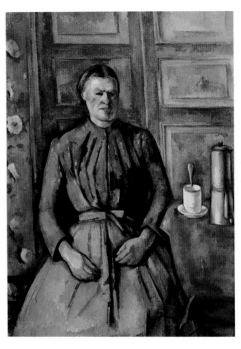

*Woman with Coffeepot*, c. 1895.
Oil on canvas, 51¼ x 37¾ in. (130 x 96 cm).
Musée d'Orsay, Paris.

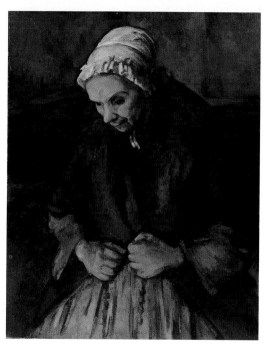

*Old Woman with a Rosary*, 1895–96.
Oil on canvas, 33½ x 25⅝ in. (85 x 65.5 cm).
The National Gallery, London.

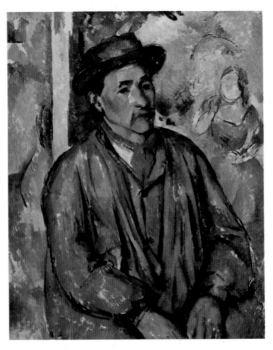

*Man in a Blue Smock*, 1895–97.
Oil on canvas, 32⅛ x 25½ in. (81.5 x 64.8 cm).
Kimbell Art Museum, Fort Worth.

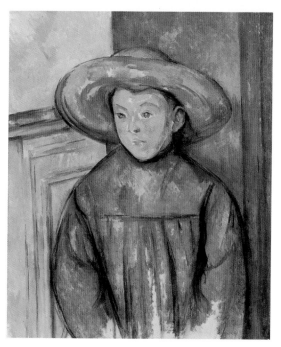

*Boy with Straw Hat,* 1896.
Oil on canvas, 27¼ x 22⅞ in. (69.9 x 58.1 cm).
Los Angeles County Museum of Art.

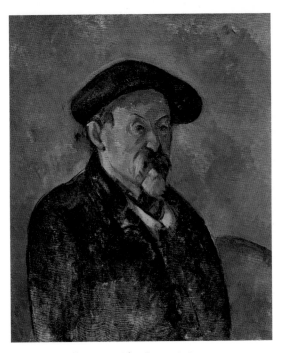

*Self-Portrait with a Beret,* 1898–1900.
Oil on canvas, 25¼ x 21 in. (64 x 53.5 cm).
Museum of Fine Arts, Boston.

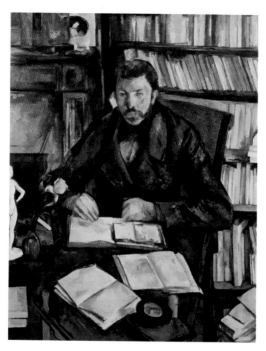

*Portrait of Gustave Geffroy*, 1895–96.
Oil on canvas, 45½ x 35 in. (116 x 89 cm).
Musée d'Orsay, Paris.

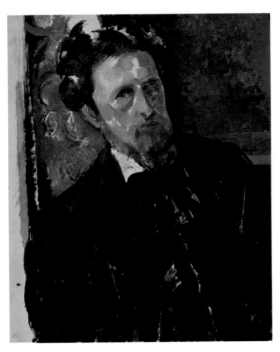

*Portrait of Joachim Gasquet*, 1896.
Oil on canvas, 25⅝ x 21¼ in. (65 x 54 cm).
National Gallery, Prague.

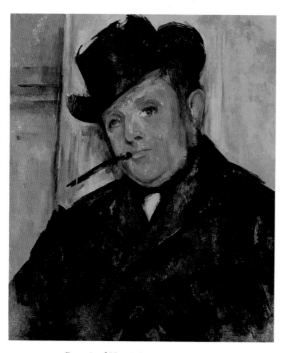

*Portrait of Henri Gasquet*, 1896–97.
Oil on canvas, 21¾ x 18⅛ in. (55 x 46 cm).
Marion Koogler McNay Art Museum, San Antonio, Texas.

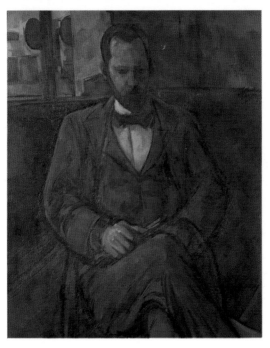

*Ambroise Vollard,* 1899.
Oil on canvas, 39½ x 32 in. (100.3 x 81.3 cm).
Musée du Petit Palais, Paris.

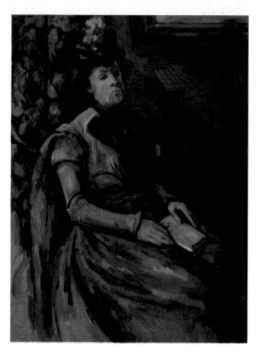

*Seated Woman in Blue,* 1902–6.
Oil on canvas, 26 x 19⅝ in. (66 x 49.8 cm).
The Phillips Collection, Washington, D.C.

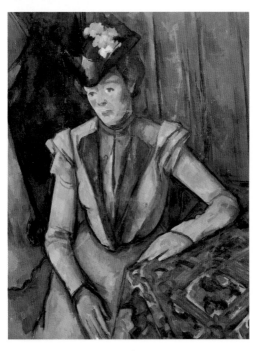

*Woman in Blue*, 1902–6.
Oil on canvas, 34⅝ x 28 in. (88 x 71 cm).
Hermitage Museum, Saint Petersburg.

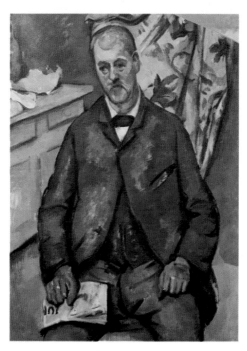

*Seated Man*, 1898–1900.
Oil on canvas, 40¼ x 29¾ in. (102.5 x 75.5 cm).
Nasjonalgalleriet, Oslo.

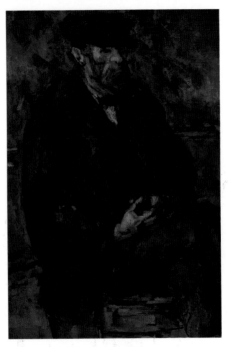

*The Gardener Vallier,* c. 1905.
Oil on canvas, 42¼ x 29⅜ in. (107.4 x 74.5 cm).
National Gallery of Art, Washington, D.C.

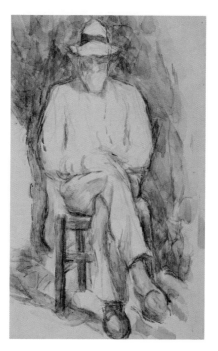

*Portrait of the Gardener Vallier,* 1906.
Graphite and watercolor on paper, 18¾ x 12⅜ in.
(48 x 31.5 cm). The National Gallery, London.

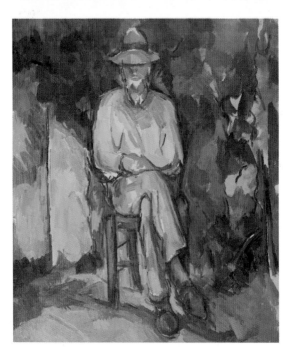

*Vallier Seated (The Gardener),* 1905–6.
Oil on canvas, 24¾ x 20½ in. (63 x 52 cm).
The Tate Gallery, London.

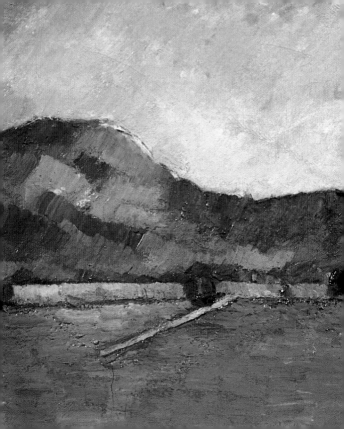

# LANDSCAPES

It is sometimes difficult to believe that the same hand painted Cézanne's relatively crisp, firmly structured "Impressionist" landscapes of the 1870s and '80s and the pulsating, loosely painted (but no less solid) images of his last decade. Yet the impulse is the same. The discontinuous, shimmering brush marks of the earlier works may seem related to Impressionism's broken stroke and divided color, but in fact, they have nothing to do with optical mixing of hues. Instead, they diagram the relation of the form—or space—to the painter's eye. We can follow Cézanne's careful examination of the angles of roofs, the swell of foliage, the furrows of rocks, along the nervous path of his probing brush. The skin of paint seems to swell into a kind of illusory relief that paradoxically seems perfectly congruent with the flat surface of the canvas, not a depiction of something observed but an equivalent for experience.

In Cézanne's astonishing late landscapes, a steady, allover rhythm of wedge-shaped marks dominates, a dense, vibrating orchestration of colored planes. Crashing chords of warm and cool hues magically call up the flat sweep of a plain, the enormous flank of a mountain, the mobile bulk of treetops—and more—without looking

specifically like any of these things. The autumnal color of these late works seems independent of place or season, serving only to suggest visual weight.

Yet, at the same time, Cézanne's landscapes are unshakably specific. To visit "Cézanne's places" is to discover how dependent he was on his surroundings for his palette of dull reds, dusty greens, chalky ochers, and cool blues, for his clear light and his boldly defined space. It is to discover, too, how completely he transformed these elements in his paintings, while remaining faithful to their essential character. The Provençal landscape where Cézanne was born and lived most of his life is austere and arid but also deeply sensuous, like the artist himself—the painter of passionate bacchanals who turned that passion into a judicious weighing of tonal nuances.

The hills and cliffs near Aix are of bleached limestone; the fields are stony. But those same bony hills and dry fields are perfumed with rosemary, lavender, and the scent of umbrella-shaped pignon pines. In summer, cicadas buzz at top volume. The light is ferocious, flattening details and carving out essentials; even deep shade is luminous. The pale limestone changes color hourly, from rose pink to creamy ocher to dull violet; on overcast days, it is a leaden gray, and in moonlight it is radiant. Curiously, Cézanne is supposed to have disliked painting in sunshine—at least at the end of his

life—preferring gray days. "Light," he wrote in 1904, "does not exist for a painter," maintaining that what we classify as "light, half-tone, or quarter-tone" are not tones at all, but "color sensations."

Just as Cézanne repeatedly painted the same objects in his still lifes, he returned over and over to the same places. Near Paris there was Auvers, home of the doctor-collector Paul Gachet, who treated van Gogh; or Pontoise, up the Seine, where Cézanne worked closely with Pissarro. Occasionally he went to the Mediterranean, but he was most fascinated by a handful of places in and around Aix. Cézanne returned obsessively to these motifs, just as Courbet repeatedly confronted the stony cliffs and dark pools of his native Franche-Comté, and Claude Monet systematically catalogued, in changing light, the rows of poplars, the garden, and the lily pond of Giverny. The list of "Cézanne's places" is familiar: the Bibémus quarry, the family house at Jas de Bouffan, the Château Noir, and most of all, Mont Sainte-Victoire.

For more than twenty years Cézanne painted "his" mountain, sometimes pulling back so that its unmistakable profile rises in the distance, sometimes coming so close that it swells toward the viewer. Whatever the vantage point, Mont Sainte-Victoire is a broad, matriarchal presence, a kind of abstracted mother goddess crouched protectively above the long plain. The architectural historian

Vincent Scully convincingly connects the choice of sites for ancient temples and shrines with landscape features that served as metaphors for the gods of remote antiquity—places held sacred long before there was architecture. Cézanne's images of Mont Sainte-Victoire, at once as solid as the mountain itself and as ephemeral as the light that illuminates it, are modern-day icons. They reveal not only the visual intelligence of one of the greatest of all painters, but they suggest as well the persistent echoes of those ancient divinities and their ability, in new guises, to engage us and to move us deeply.

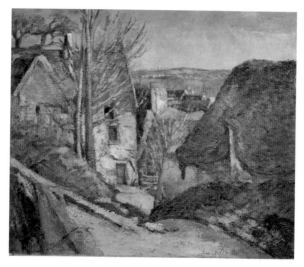

*House of the Hanged Man,* 1873.
Oil on canvas, 21⅝ x 26 in. (55 x 66 cm).
Musée d'Orsay, Paris.

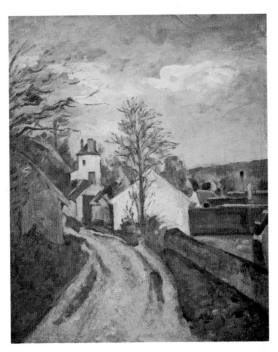

*Dr. Gachet's House at Auvers,* c. 1873.
Oil on canvas, 18 x 15 in. (46 x 38 cm).
Musée d'Orsay, Paris.

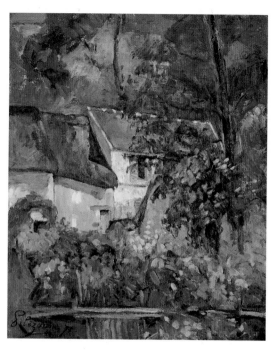

*House of Père Lacroix,* 1873.
Oil on canvas, 24⅛ x 20 in. (61.3 x 50.6 cm).
National Gallery of Art, Washington, D.C.

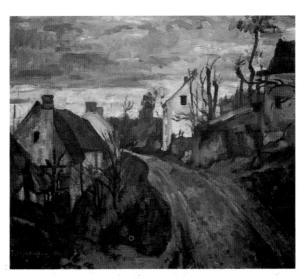

*Village Road, Auvers,* c. 1872–73.
Oil on canvas, 18 x 21¾ in. (46 x 55 cm).
Musée d'Orsay, Paris.

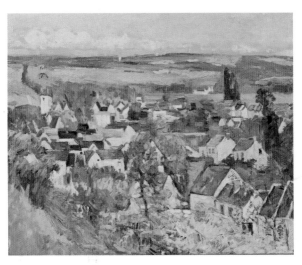

*Auvers, Panoramic View*, c. 1873.
Oil on canvas, 25½ x 32 in. (65.2 x 81.3 cm).
The Art Institute of Chicago.

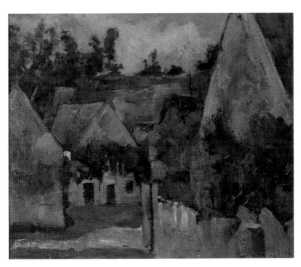

*Crossroads of the Rue Remy, Auvers,* c. 1873.
Oil on canvas, 15 x 18 in. (38 x 46 cm).
Musée d'Orsay, Paris.

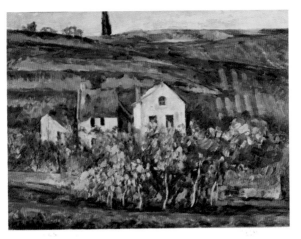

*Little Houses in Auvers*, c. 1873–74.
Oil on canvas, 15¾ x 21½ in. (30.7 x 40 cm). Fogg Art
Museum, Harvard University, Cambridge, Massachusetts.

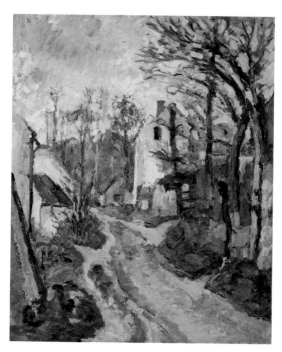

*The Road at Auvers-sur-Oise,* 1873–74.
Oil on canvas, 21⅝ x 18⅛ in. (55.2 x 46.2 cm).
National Gallery of Canada, Ottawa.

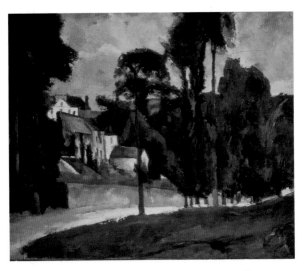

*Landscape at Pontoise: The Property of "Les Mathurins,"* 1875–77.
Oil on canvas, 22¾ x 27⅞ in. (58 x 71 cm).
Pushkin Museum of Fine Arts, Moscow.

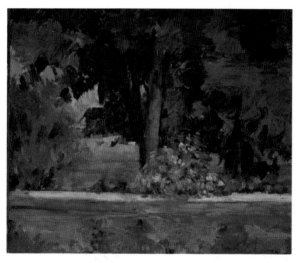

*Lake at the Jas de Bouffan,* c. 1876.
Oil on canvas, 18⅛ x 22⅛ in. (46 x 56.2 cm).
Sheffield City Museum, Sheffield, England.

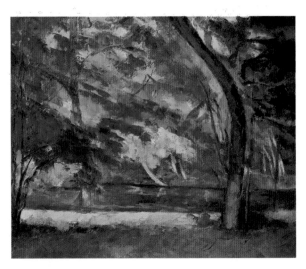

*Pond at Les Soeurs,* 1877.
Oil on canvas, 24 x 29¼ in. (60 x 74 cm).
Courtauld Institute Galleries, London.

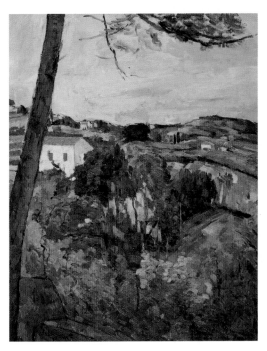

*Landscape with Red Roof (The Pine at L'Estaque)*, 1876.
Oil on canvas, 28⅝ x 23⅝ in. (73 x 60 cm).
Musée de l'Orangerie, Paris.

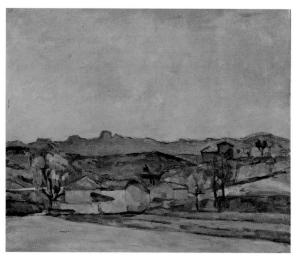

*La Chaine de L'Etoile avec le Pilon du Roi*, 1878–79.
Oil on canvas, 19⅜ x 23¼ in. (49.2 x 59 cm).
Glasgow Museums: Art Gallery and Museum.

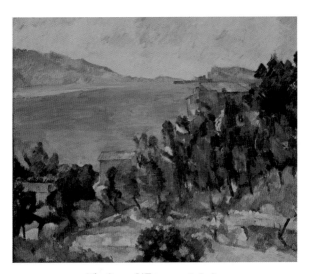

*The Sea at L'Estaque,* 1878–82.
Oil on canvas, 21¼ x 25⅝ in. (54 x 65 cm). Memorial Art
Gallery of the University of Rochester, Rochester, New York.

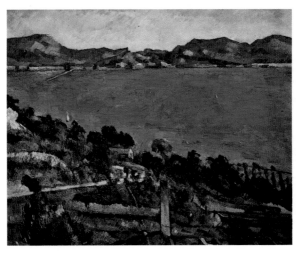

*L'Estaque: View of the Bay of Marseilles,* c. 1878–79.
Oil on canvas, 23¼ x 28⅝ in. (59 x 73 cm).
Musée d'Orsay, Paris.

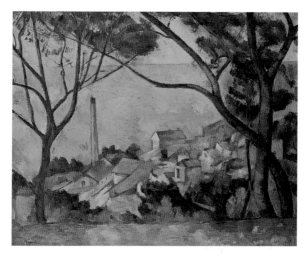

*Sea at L'Estaque,* 1878–79.
Oil on canvas, 28⅝ x 36¼ in. (73 x 92 cm).
Musée Picasso, Paris.

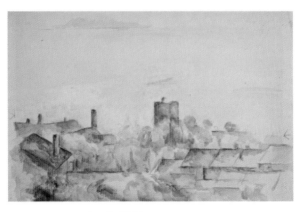

*Roofs of L'Estaque,* 1878–82.
Watercolor and graphite on paper, 12⅛ x 18⅝ in. (30.6 x 47.2 cm). Museum Boymans-van Beuningen, Rotterdam.

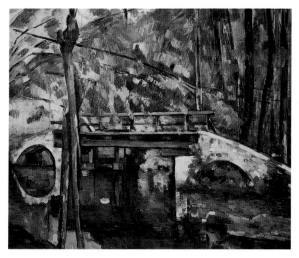

*The Bridge of Maincy near Melun*, c. 1879.
Oil on canvas, 23½ x 28⅝ in. (60 x 73 cm).
Musée d'Orsay, Paris.

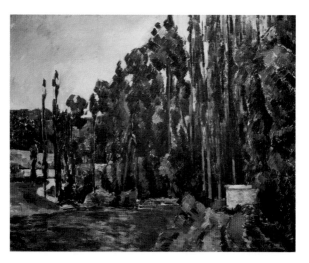

*Poplars,* c. 1879–80.
Oil on canvas, 25½ x 31½ in. (65 x 80 cm).
Musée d'Orsay, Paris.

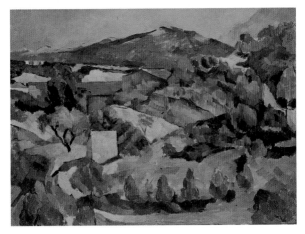

*Mountains in Provence (near L'Estaque?)*, c. 1879.
Oil on canvas, 21 x 28½ in. (53.5 x 72.4 cm).
National Museum and Gallery of Wales, Cardiff.

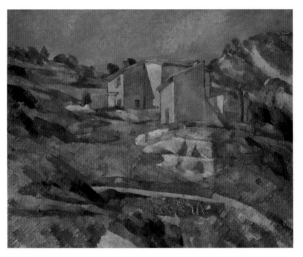

*Houses in Provence—The Valley of the Riaux near L'Estaque,*
1879–82. Oil on canvas, 25½ x 32 in. (64.7 x 81.2 cm).
National Gallery of Art, Washington, D.C.

*The Château of Médan,* 1879–81.
Watercolor on paper, 12¼ x 18½ in. (31 x 47 cm).
Kunsthaus Zurich.

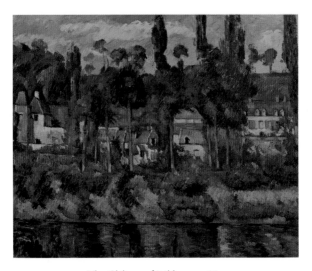

*The Château of Médan*, c. 1880.
Oil on canvas, 23¼ x 28⅝ in. (59 x 72 cm).
Glasgow Museums: The Burrell Collection, Glasgow.

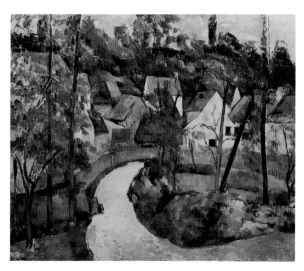

*Bend in the Road*, c. 1881.
Oil on canvas, 23⅞ x 28⅞ in. (60.5 x 73.5 cm).
Museum of Fine Arts, Boston.

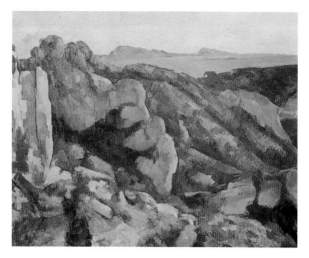

*Rocks at L'Estaque,* 1879–82.
Oil on canvas, 28⅝ x 35⅝ in. (73 x 91 cm). Museu de Arte
de São Paulo Assis Chateaubriand, São Paulo, Brazil.

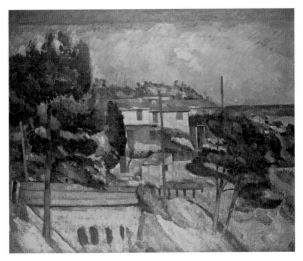

*The Viaduct at L'Estaque*, 1882–85.
Oil on canvas, 21¼ x 25¾ in. (54 x 65.5 cm).
Ateneumin Taidemuseo, Helsinki, Finland.

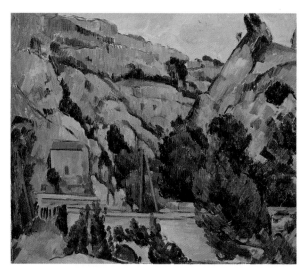

*The Viaduct at L'Estaque,* 1882–85.
Oil on canvas, 17¼ x 21 in. (43.8 x 53.3 cm). Allen Memorial
Art Museum, Oberlin College, Oberlin, Ohio.

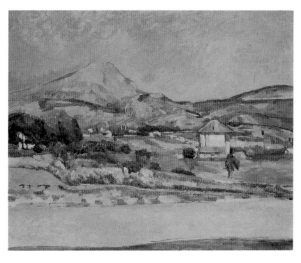

*Mont Sainte-Victoire,* 1882–85.
Oil on canvas, 22¾ x 28¼ in. (58 x 72 cm).
Pushkin Museum of Fine Arts, Moscow.

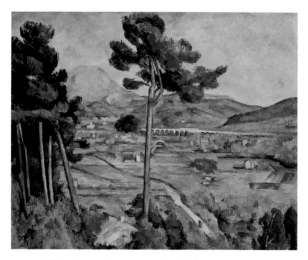

*Mont Sainte-Victoire Seen from Bellevue,* 1882–85.
Oil on canvas, 25¾ x 32⅛ in. (65.5 x 81.7 cm).
The Metropolitan Museum of Art, New York.

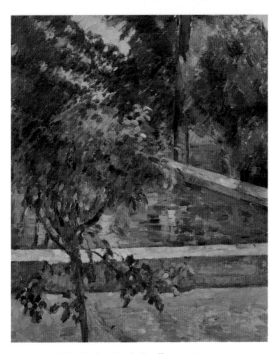

*The Pool at Jas de Bouffan,* 1878–79.
Oil on canvas, 29 x 23¾ in. (73.5 x 60.5 cm).
Albright-Knox Art Gallery, Buffalo.

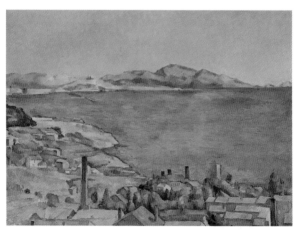

*The Gulf of Marseilles Seen from L'Estaque,* 1884.
Oil on canvas, 28¾ x 39½ in. (78 x 100 cm).
The Metropolitan Museum of Art, New York.

*Pine and Mont Sainte-Victoire,* 1883–86.
Pencil on paper, 12¼ x 18⅞ in. (31 x 48.2 cm).
Museum Boymans-van Beuningen, Rotterdam.

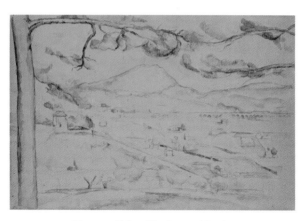

*Montagne Sainte-Victoire,* c. 1883–87.
Graphite, watercolor, and gouache on paper, 13⅝ x 28⅞ in.
(34.4 x 53.7 cm). The Art Institute of Chicago.

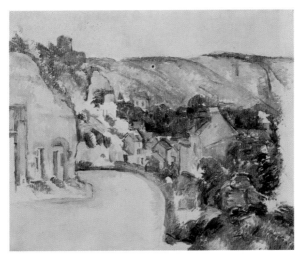

*A Turn in the Road at La Roche-Guyon*, 1885.
Oil on canvas, 24½ x 29¾ in. (62.2 x 75.5 cm).
Smith College Museum of Art, Northampton, Massachusetts.

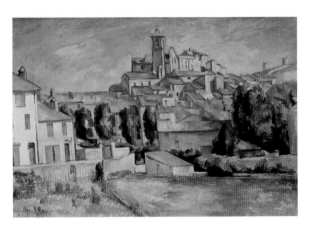

*The Village of Gardanne,* 1885–86.
Oil on canvas, 25⅝ x 39⅜ in. (65 x 100 cm).
The Barnes Foundation, Merion, Pennsylvania.

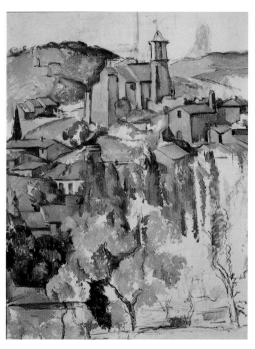

*The Village of Gardanne,* 1885–86.
Oil on canvas, 36¼ x 29⅜ in. (92 x 74.5 cm).
The Brooklyn Museum.

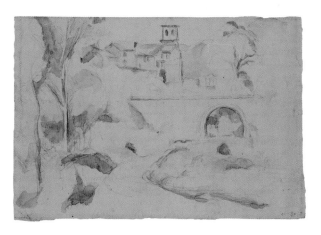

*The Bridge at Gardanne*, 1885–86.
Watercolor and graphite on paper, 8⅛ x 12¼ in.
(20.6 x 31.1 cm). The Museum of Modern Art, New York.

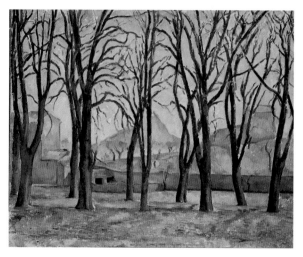

*Chestnut Trees, Jas de Bouffan,* 1885–86.
Oil on canvas, 28¾ x 38¼ in. (73 x 97 cm).
The Minneapolis Institute of Arts.

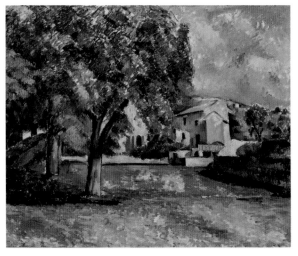

*Jas de Bouffan,* 1885–87.
Oil on canvas, 28¼ x 35¾ in. (72 x 91 cm).
Pushkin Museum of Fine Arts, Moscow.

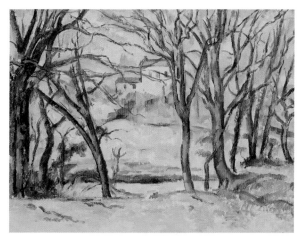

*Trees and Houses,* 1885–87.
Oil on canvas, 26¾ x 36⅛ in. (68 x 92 cm).
The Metropolitan Museum of Art, New York.

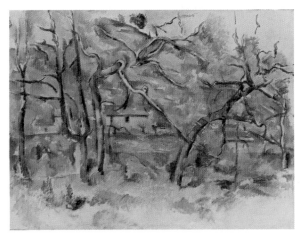

*Landscape from Provence,* 1885–87.
Oil on canvas, 23½ x 31¾ in. (60 x 81 cm).
Nasjonalgalleriet, Oslo.

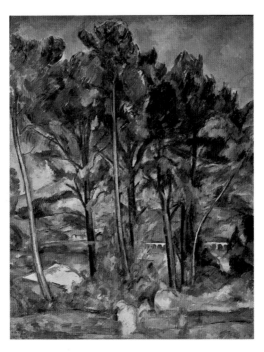

*The Aqueduct*, 1885–87.
Oil on canvas, 35¾ x 28¼ in. (91 x 72 cm).
Pushkin Museum of Fine Arts, Moscow.

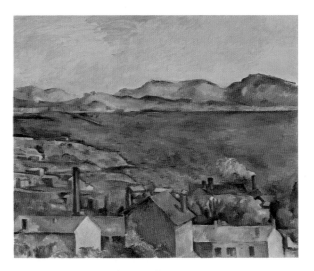

*The Bay of Marseilles, Seen from L'Estaque,* c. 1886–90.
Oil on canvas, 31½ x 39⅝ in. (80.2 x 100.6 cm).
The Art Institute of Chicago.

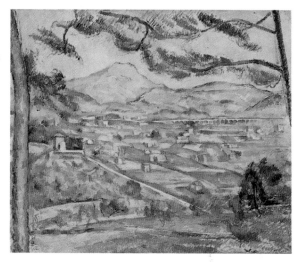

*Mont Sainte-Victoire with Large Pine,* 1886–87.
Oil on canvas, 23¾ x 28⅝ in. (60 x 73 cm).
The Phillips Collection, Washington, D.C.

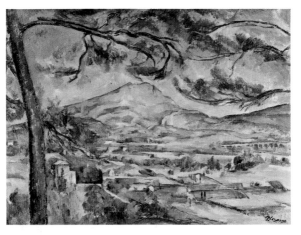

*Mont Sainte-Victoire with Large Pine*, c. 1887.
Oil on canvas, 25⅞ x 35⅜ in. (66 x 90 cm).
Courtauld Institute Galleries, London.

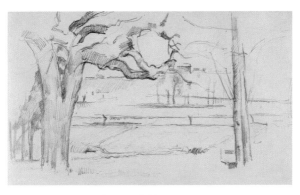

*Landscape with Trees*, 1885–87.
Pencil on paper, 31½ x 55 in. (12.4 x 21.7 cm).
The Art Institute of Chicago.

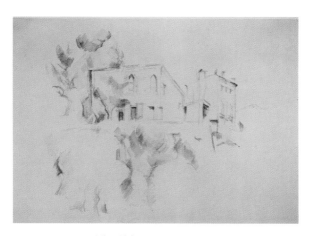

*The Château Noir*, 1887–90.
Graphite and watercolor on paper, 12⅜ x 19 in. (31.5 x 48.5 cm). Museum Boymans-van Beuningen, Rotterdam.

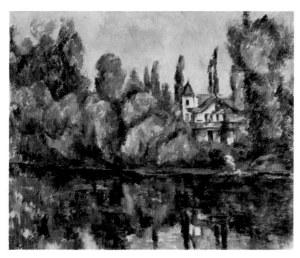

*The Banks of the Marne*, 1888.
Oil on canvas, 25½ x 31⅞ in. (65 x 81 cm).
Hermitage Museum, Saint Petersburg.

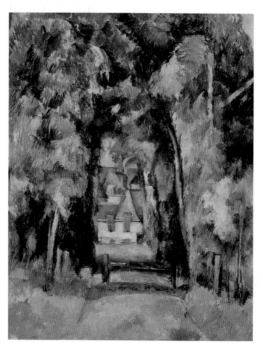

*Allée at Chantilly,* 1888.
Oil on canvas, 29½ x 24⅝ in. (75 x 63 cm).
The Toledo Museum of Art, Toledo, Ohio.

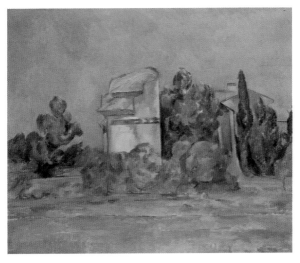

*The Pigeon Tower at Bellevue,* c. 1894–96.
Oil on canvas, 25⅛ x 31½ in. (64.1 x 80 cm).
The Cleveland Museum of Art.

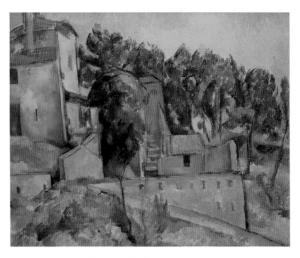

*House at Bellevue,* c. 1890.
Oil on canvas, 23½ x 28⅝ in. (60 x 73 cm).
Private collection, Geneva.

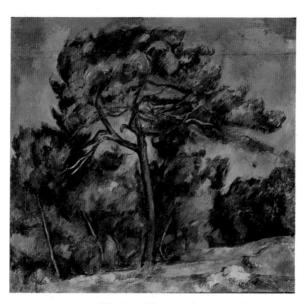

*The Large Pine,* c. 1889.
Oil on canvas, 33⅜ x 36¼ in. (84 x 92 cm). Museu de Art
de São Paulo Assis Chateaubriand, São Paulo, Brazil.

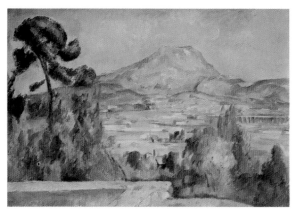

*Mont Sainte-Victoire*, c. 1890.
Oil on canvas, 24½ x 36¼ in. (62 x 92 cm).
Musée d'Orsay, Paris.

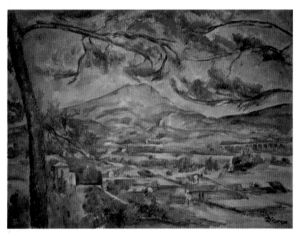

*Mont Sainte-Victoire,* c. 1890.
Watercolor and charcoal on paper, 12⅜ x 18¾ in.
(31.5 x 47.5 cm). Courtauld Institute Galleries, London.

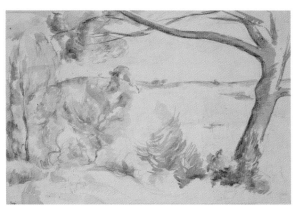

*Pine Trees at Bellevue,* 1879–85.
Watercolor over pencil on paper, 12¼ x 18⅞ in.
(31.2 x 47.9 cm). Allen Memorial Art Museum,
Oberlin College, Oberlin, Ohio.

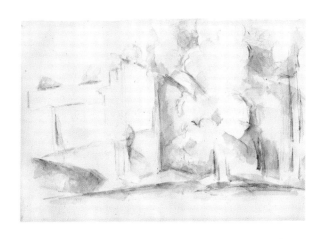

*House among the Trees,* 1890–94.
Watercolor and graphite on paper, 11 x 17⅛ in.
(27.9 x 43.5 cm). The Museum of Modern Art, New York.

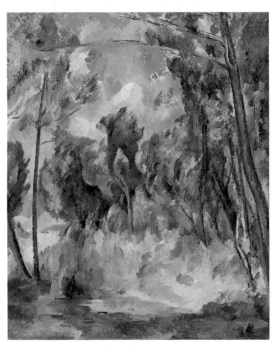

*The Glade*, 1890.
Oil on canvas, 39½ x 32 in. (100 x 81 cm).
The Toledo Museum of Art, Toledo, Ohio.

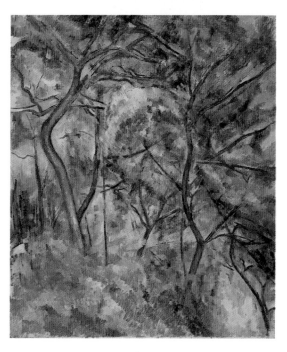

*Woods,* 1894.
Oil on canvas, 45¹³/₁₆ x 32 in. (116.2 x 81.3 cm).
Los Angeles County Museum of Art.

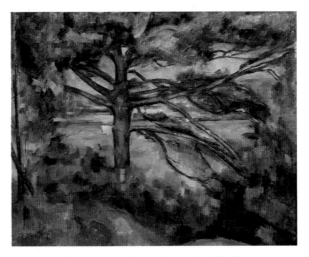

*Large Pine Tree near Aix (Large Pine and Red Earth)*, 1890–95.
Oil on canvas, 28¼ x 35⅞ in. (72 x 91 cm).
Hermitage Museum, Saint Petersburg.

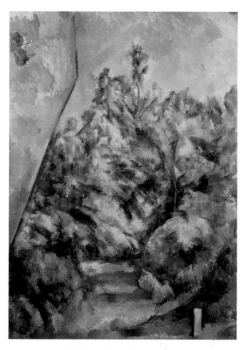

*The Red Rock,* c. 1895.
Oil on canvas, 36¼ x 26¾ in. (92 x 68 cm).
Musée de l'Orangerie, Paris.

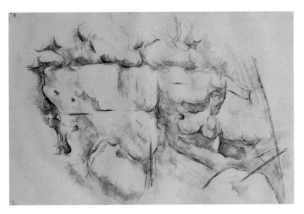

*Rocks near the Caves above the Château Noir*, 1895–1900.
Graphite and watercolor on paper, 12½ x 18¾ in.
(31.7 x 47.6 cm). The Museum of Modern Art, New York.

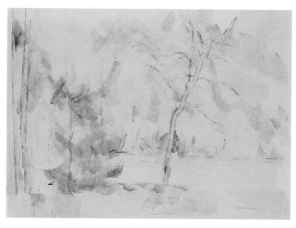

*Corner of Lac d'Annecy,* 1897.
Watercolor on white wove paper, 17⅜ x 22⅝ in.
(44 x 57.5 cm). The Saint Louis Art Museum.

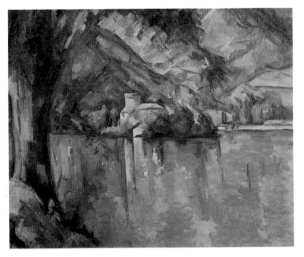

*Lac d'Annecy,* 1896.
Oil on canvas, 26 x 31⅞ in. (65 x 81 cm).
Courtauld Institute Galleries, London.

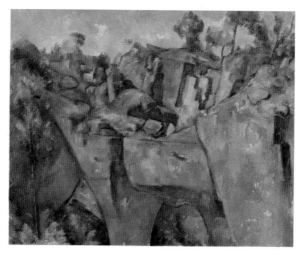

*Bibémus Quarry,* c. 1895.
Oil on canvas, 25½ x 31½ in. (65 x 80 cm).
Museum Folkwang, Essen, Germany.

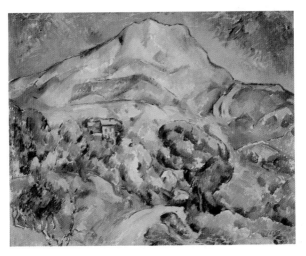

*Mont Sainte-Victoire above the Tholonet Road,* 1896–98.
Oil on canvas, 30¾ x 39 in. (78 x 99 cm).
Hermitage Museum, Saint Petersburg.

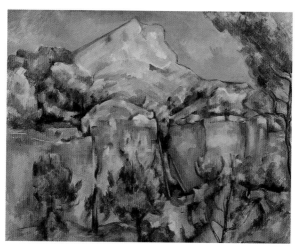

*Mont Sainte-Victoire Seen from the Bibémus Quarry*, c. 1897.
Oil on canvas, 25⅝ x 31⅞ in. (65 x 81 cm).
The Baltimore Museum of Art.

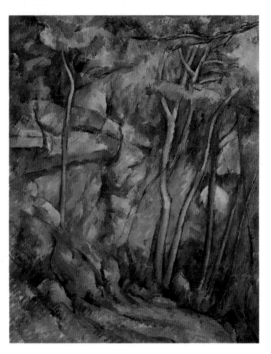

*In the Park of the Château Noir*, 1898–1900.
Oil on canvas, 36¼ x 28⅞ in. (92 x 73 cm).
Musée de l'Orangerie, Paris.

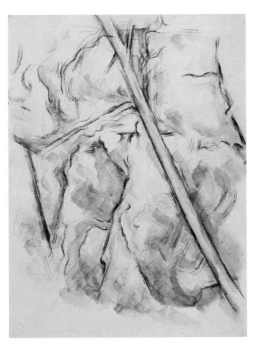

*Pine and Rocks at the Château Noir*, 1895–1900.
Watercolor and graphite on paper, 12½ x 18¾ in.
(46.5 x 35.5 cm). The Art Museum, Princeton University,
Princeton, New Jersey.

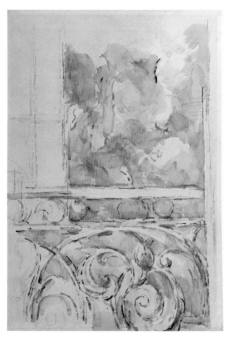

*The Balcony*, c. 1900.
Graphite and watercolor on paper, 21¼ x 15⅞ in.
(55 x 39 cm). Philadelphia Museum of Art.

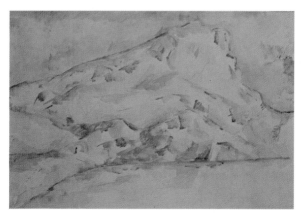

*Mont Sainte-Victoire,* c. 1900.
Watercolor and graphite on paper, 12¼ x 18¾ in.
(31.1 x 47.9 cm). Musée du Louvre, Paris.

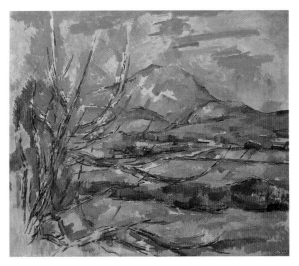

*Mont Sainte-Victoire,* 1900–1902.
Oil on canvas, 21½ x 25½ in. (54.6 x 64.8 cm).
National Gallery of Scotland, Edinburgh.

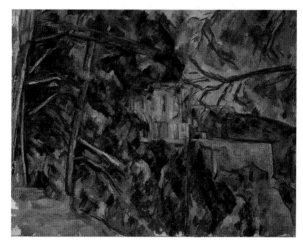

*The Château Noir,* 1900–1904.
Oil on canvas, 29 x 38 in. (74 x 96.5 cm).
National Gallery of Art, Washington, D.C.

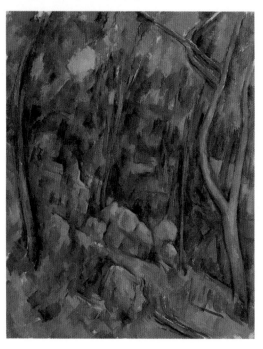

*Rocks and Trees (Park of the Château Noir)*, 1900–1904.
Oil on canvas, 36¼ x 28⅞ in. (92 x 73 cm).
The National Gallery, London.

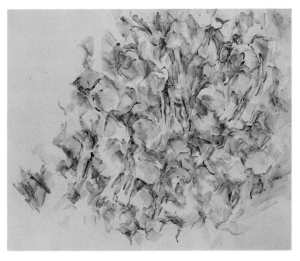

*Foliage,* 1895–1900.
Watercolor and graphite on paper, 17⅝ x 22⅜ in.
(44.8 x 58.6 cm). The Museum of Modern Art, New York.

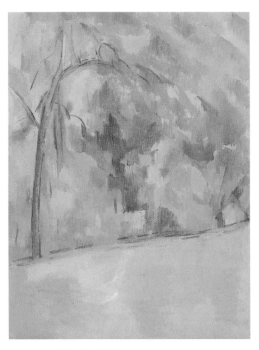

*Morning in Provence,* 1900–1906.
Oil on canvas, 32 x 24⅞ in. (81 x 63 cm).
Albright-Knox Art Gallery, Buffalo.

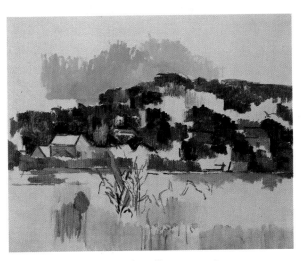

*Houses on the Hill,* 1900–1906.
Oil on canvas, 25¾ x 32 in. (65.5 x 81 cm).
Marion Koogler McNay Art Museum, San Antonio, Texas.

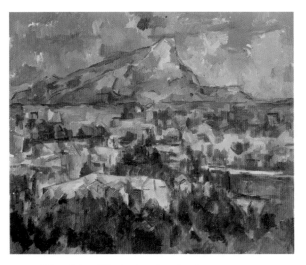

*Mont Sainte-Victoire Seen from Les Lauves,* 1902–4.
Oil on canvas, 28¾ x 36⅟₁₆ in. (73 x 91.9 cm).
Philadelphia Museum of Art.

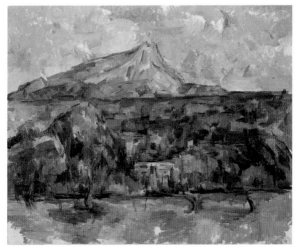

*Mont Sainte-Victoire Seen from Les Lauves,* 1902–6.
Oil on canvas, 25½ x 32 in. (64.8 x 81.3 cm).
The Nelson-Atkins Museum of Art, Kansas City, Missouri.

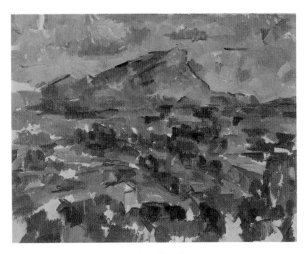

*Mont Sainte-Victoire Seen from Les Lauves*, 1902–6.
Oil on canvas, 25 x 32¾ in. (63.5 x 83 cm).
Kunsthaus Zurich.

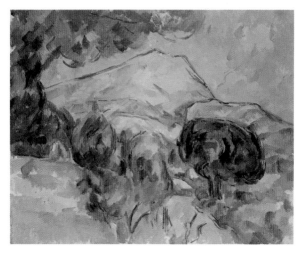

*Mont Sainte-Victoire above the Tholonet Road*, c. 1904.
Oil on canvas, 28⅜ x 36⅜ in. (72.2 x 92.4 cm).
The Cleveland Museum of Art.

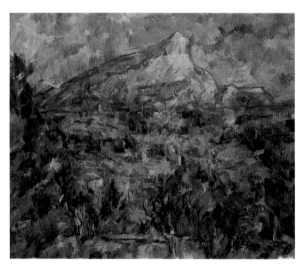

*Mont Sainte-Victoire Seen from Les Lauves,* 1904–5.
Oil on canvas, 23⅝ x 28¾ in. (60 x 73 cm).
Pushkin Museum of Fine Arts, Moscow.

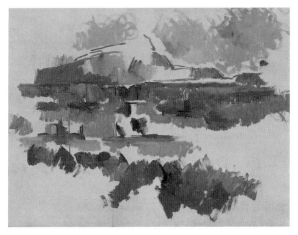

*Mont Sainte-Victoire Seen from Les Lauves,* 1904–6.
Oil on canvas, 21¼ x 28¾ in. (54 x 73 cm).
Galerie Beyeler, Basel, Switzerland.

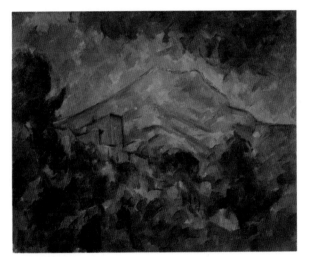

*Mont Sainte-Victoire and the Château Noir,* 1904–6.
Oil on canvas, 25¾ x 31¾ in. (65.6 x 81 cm).
Bridgestone Institute of Art, Tokyo.

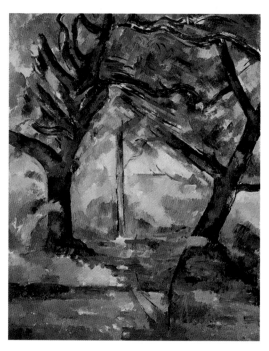

*The Big Trees,* c. 1904.
Oil on canvas, 31¾ x 25½ in. (81 x 65 cm).
National Gallery of Scotland, Edinburgh.

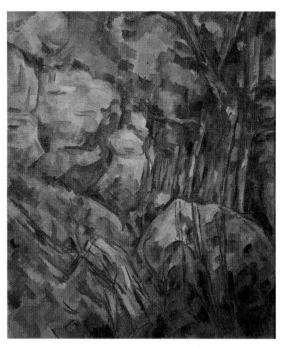

*Rocks near the Caves above the Château Noir,* c. 1904.
Oil on canvas, 25½ x 21¼ in. (65 x 54 cm).
Musée d'Orsay, Paris.

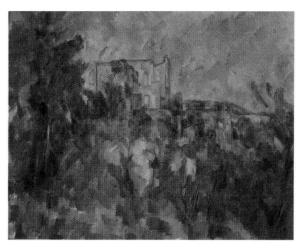

*View of the Château Noir*, 1905.
Oil on canvas, 28¾ x 36¼ in. (73 x 92 cm).
Musée Picasso, Paris.

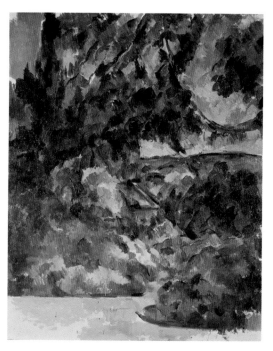

*Blue Landscape*, 1904–6.
Oil on canvas, 40⅛ x 35⅝ in. (102 x 83 cm).
Hermitage Museum, Saint Petersburg.

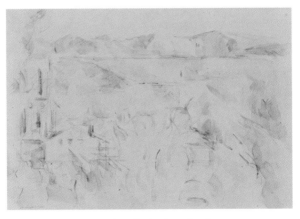

*Aix Cathedral Seen from the Studio at Les Lauves,* 1902–4.
Pencil and watercolor on paper, 12½ x 18½ in. (31 x 47 cm).
Philadelphia Museum of Art.

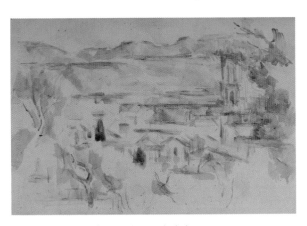

*Landscape: Aix Cathedral,* 1904–6.
Watercolor over graphite on paper,
12⅝ x 18⅞ in. (32 x 48 cm). Musée Picasso, Paris.

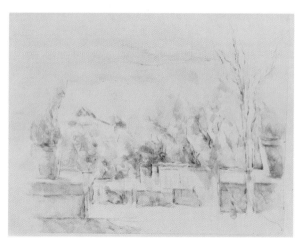

*The Garden at Les Lauves,* 1902–6.
Pencil and watercolor on paper, 16⅞ x 21¼ in. (43 x 54 cm).
The Pierpont Morgan Library, New York.

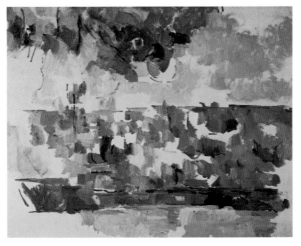

*The Garden at Les Lauves,* c. 1906.
Oil on canvas, 25¾ x 32 in. (65.5 x 81.3 cm).
The Phillips Collection, Washington, D.C.

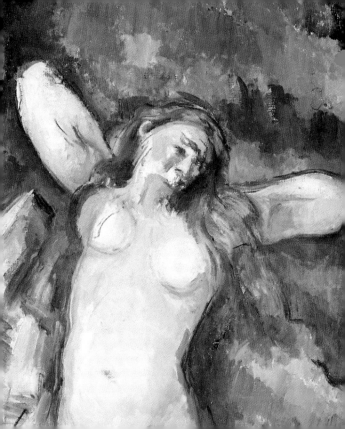

# BATHERS

In the spring of 1904 Cézanne wrote to Emile Bernard that he had regretfully abandoned his "project of doing Poussin over entirely from nature, . . . of painting a living Poussin in the open air, with color and light, instead of one of those works imagined in a studio, where everything has the brown color of feeble daylight without reflections from the sky and the sun." The idea was not unique. Painting life-size figures in a landscape was an early goal of the Impressionists; Manet's studio composite *Luncheon on the Grass* (Musée d'Orsay, Paris), with its shocking mix of unabashedly naked women and men in ordinary street clothes, was the most notorious example, but Monet had also tackled the motif in a couple of enormous, stunningly immediate canvases of his friends at a picnic and women in white dresses in a sun-dappled garden, both painted *en plein air.*

What Cézanne aspired to, however, was not a casual scene of modern life, like Manet's or Monet's, but something closer to the tradition of heroic figure painting— a becalmed, rational version of the fantastic orgies and perfervid bacchanals of his early years, their passionate unease disciplined by a lifetime's close observation of nature. He

wished to paint a timeless scene of bathers the way Poussin might have, had he been Cézanne's contemporary, a picture with the unity of figure and setting, the sense of firm geometric underpinning and logic, that informs every element in the work of that seventeenth-century *peintre-philosophe.* But Cézanne wanted to achieve this without the schematic plotting of even the best of Neo-Classicism, substituting instead the directness, immediacy, and sense of intuitive order that were the hallmarks of his own best work and that of his fellow "new painters."

For years Cézanne had made small, often superb pictures of male and female bathers, with the sexes usually carefully segregated. He complained, however, that there were too many obstacles to realizing the large version he envisaged: finding a site that corresponded to his ideas, "the difficulty of carrying about a large canvas," the vicissitudes of weather, and perhaps most daunting, getting the necessary number of models— "men and women willing to undress and remain motionless in the poses I had determined." Nevertheless, in the last years of his life, Cézanne *did* paint a series of large-scale bathers, magnificent inventions that fulfill the implications of his smaller versions. They remain among the most arresting, influential pictures of the twentieth century.

Cézanne's desire to integrate figures and landscape setting is palpable in all of his bathers, whatever their scale; in the large paintings, it is fully achieved. Human limbs and tree branches bend to the same rhythms; torsos and tree trunks swell and narrow to the same dimensions. The same repetitive touch (slowly deposited wedges of pigment, all oriented the same way) and the same nervous drawing (stuttering marks that track the path of a surface as it slips around a form) conspire to knit together naked bodies and forested riverbanks. The same nuanced hues—rose pink, dull ocher, and atmospheric blue—evoke flesh and foliage, near and far, solid and void, depending upon which color (and its innumerable subtle tonal variants) dominates. Blue makes its presence felt most strongly: as line, delicately nudging forms apart, and in patches, as an equivalent for air, winnowing planes, making the entire surface of the canvas breathe, setting up an allover visual pulse that both dissolves forms and accentuates their weight.

Picasso and Matisse treasured the small Cézanne bathers that they owned. Matisse refused to part with his *Three Female Bathers* (c. 1879–82; Musée du Petit Palais, Paris) even when he and his young family were in acute financial need, because of the picture's importance to the evolution of his art. In 1936, when he at

last decided to give the painting to the City of Paris, he wrote: "[It] sustained me morally in the critical moments of my venture as an artist." Almost twenty years later, in his last series, the radical Cut-Outs of blue nudes, Matisse was still rendering homage to this little picture by his chosen master.

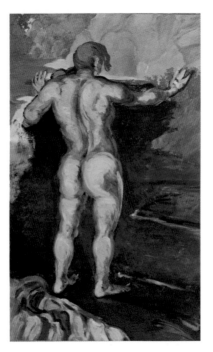

*Bather and Rocks,* c. 1867–69.
Oil on canvas, 65⅞ x 44½ in. (167.5 x 113 cm).
The Chrysler Museum, Norfolk, Virginia.

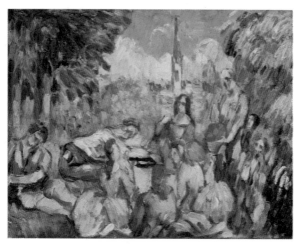

*Luncheon on the Grass,* 1873–75.
Oil on canvas, 8¼ x 10¾ in. (21 x 27 cm).
Musée de l'Orangerie, Paris.

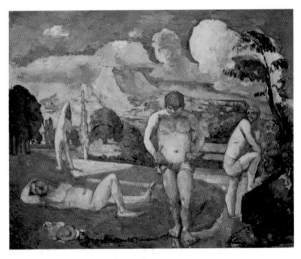

*Bathers at Rest*, 1875–76.
Oil on canvas, 32¼ x 39⅞ in. (82 x 101.2 cm).
The Barnes Foundation, Merion, Pennsylvania.

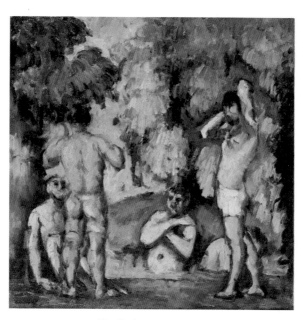

*Five Bathers*, c. 1875–77.
Oil on canvas, 9½ x 10⅝ in. (24 x 27 cm).
Musée d'Orsay, Paris.

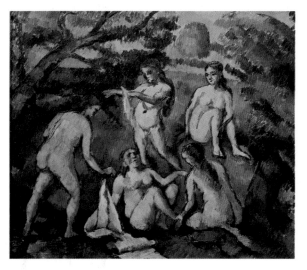

*Five Bathers,* 1877–78.
Oil on canvas, 18 x 21¾ in. (45.8 x 55.7 cm).
Musée Picasso, Paris.

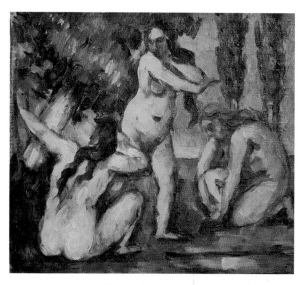

*Three Bathers*, 1875–77.
Oil on canvas, 7½ x 8¾ in. (19 x 22 cm).
Musée d'Orsay, Paris.

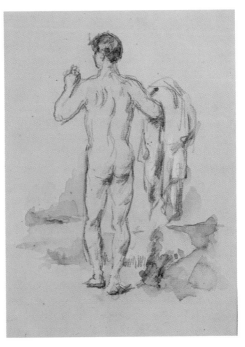

*The Bather*, 1879–82. Watercolor and graphite on paper,
8¾ x 6¾ in. (22.3 x 17.1 cm).
Wadsworth Atheneum, Hartford, Connecticut.

*The Triumph of the Feminine,* 1880–85.
Watercolor on paper, 8¼ x 10⅝ in. (21 x 27 cm).
The National Museum of Western Art, Tokyo.

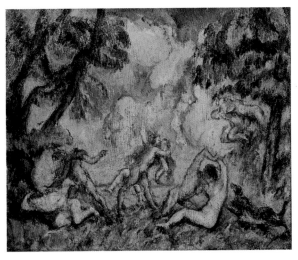

*The Battle of Love,* c. 1880.
Oil on linen, 14⅞ x 18¼ in. (37.8 x 46.2 cm).
National Gallery of Art, Washington, D.C.

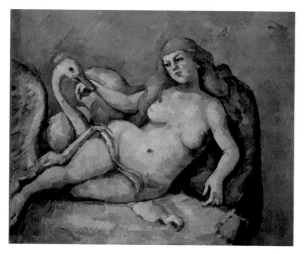

*Leda and the Swan*, 1880–82.
Oil on canvas, 23½ x 29½ in. (59.8 x 75 cm).
The Barnes Foundation, Merion, Pennsylvania.

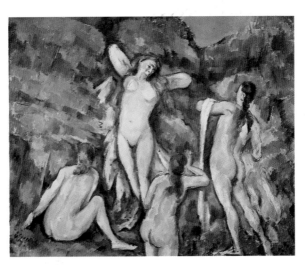

*Four Bathers,* 1888–90.
Oil on canvas, 28¾ x 36¼ in. (73 x 92 cm).
Ny Carlsberg Glyptotek, Copenhagen.

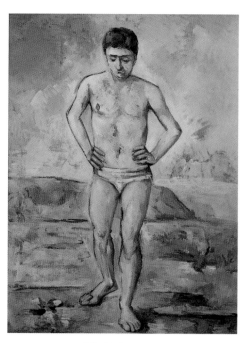

*The Bather,* 1885.
Oil on canvas, 50 x 38½ in. (127 x 96.8 cm).
The Museum of Modern Art, New York.

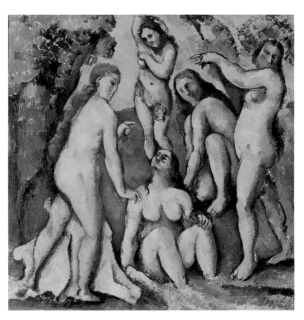

*Five Female Bathers,* 1885–87.
Oil on canvas, 25½ x 25½ in. (65 x 65 cm).
Kunstmuseum, Basel, Switzerland.

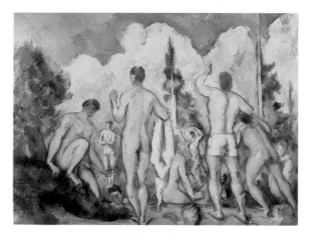

*Bathers,* c. 1890.
Oil on canvas, 23⅜ x 32¾ in. (60 x 81 cm).
Musée d'Orsay, Paris.

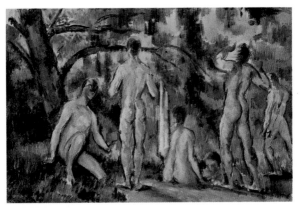

*Five Male Bathers,* 1890–92.
Oil on canvas, 10¼ x 15¾ in. (26 x 40 cm).
Pushkin Museum of Fine Arts, Moscow.

*The Boat and the Bathers,* 1890–94.
Oil on canvas, 11⅞ x 49¼ in. (30 x 125 cm).
Musée de l'Orangerie, Paris.

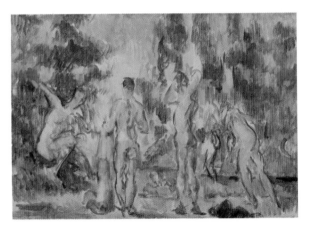

*Bathers,* 1890–1900.
Oil on canvas, 8¾ x 14 in. (22 x 35.5 cm).
Musée d'Orsay, Paris.

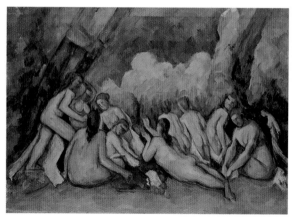

*Large Female Bathers*, 1894–1905.
Oil on canvas, 53½ x 75⅛ in. (136 x 191 cm).
The National Gallery, London.

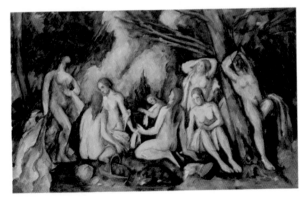

*Nudes in the Landscape,* 1900–1905.
Oil on canvas, 52⅜ x 81½ in. (133 x 237 cm).
The Barnes Foundation, Merion, Pennsylvania.

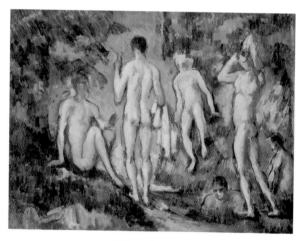

*Male Bathers*, n.d.
Oil on canvas, 11½ x 15½ in. (29.2 x 39.4 cm).
The Barnes Foundation, Merion, Pennsylvania.

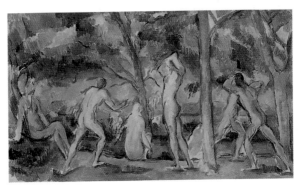

*Bathers,* 1898–1900.
Oil on canvas, 10⅝ x 18⅛ in. (27 x 46.1 cm).
The Baltimore Museum of Art.

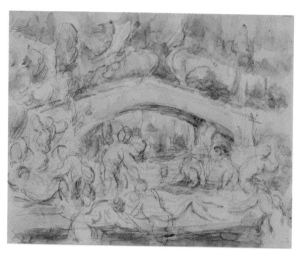

*Bathers under a Bridge,* 1895–1900.
Watercolor and graphite on paper,
8¼ x 10¾ in. (21 x 27.3 cm).
The Metropolitan Museum of Art, New York.

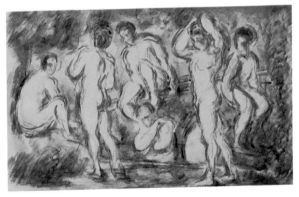

*Bathers*, c. 1900.
Pencil and watercolor on paper, 7¾ x 10¾ in. (20 x 27.3 cm).
The Pierpont Morgan Library, New York.

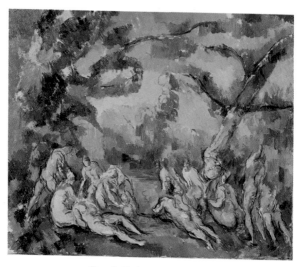

*Female Bathers*, 1899–1904.
Oil on canvas, 20⅛ x 24¼ in. (51.3 x 61.7 cm).
The Art Institute of Chicago.

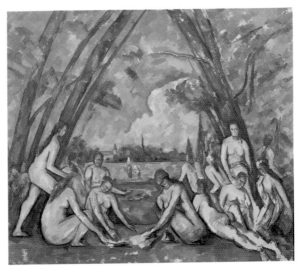

*Large Female Bathers*, 1906.
Oil on canvas, 82 x 99 in. (208.3 x 251.5 cm).
Philadelphia Museum of Art.

# CHRONOLOGY

**1839** January 19—Paul Cézanne is born in Aix-en-Provence to Louis-Auguste Cézanne and Anne-Elisabeth-Honorine Aubert.

**1844** Cézanne's parents marry.

**1852** Enters the Collège Bourbon; begins a friendship with classmate Emile Zola.

**1857** Begins studies at the Free School of Drawing of Aix (through 1861).

**1858** Enrolls in Faculty of Law, University of Aix, at his father's insistence; completes all but his final year and the second exam required to practice.

**1861** Abandons law. April–September—moves to Paris and studies at the Académie Suisse, where he meets Camille Pissarro, Achille Emperaire, and Armand Guillaumin. September—returns to Aix to work in father's bank, probably because of having failed the Academy of Fine Arts' entrance exam.

**1862** Re-enrolls at Free School of Drawing. November—returns to Paris; studies at Académie Suisse and privately. Probably attempts, again unsuccessfully, the Academy of Fine Arts entrance exam. Thereafter divides time between Paris and Aix, with stays elsewhere in France (including

L'Estaque, Auvers, Pontoise, Médan, La Roche-Guyon, Normandy). Over next few years meets group of "new painters," later known as the Impressionists, including Auguste Renoir, Edouard Manet, Claude Monet, and Frédéric Bazille.

**1865** Begins to submit works to the Salon, which are always refused.

**1872** January 4—Paul, son of Cézanne and Hortense Fiquet, is born in Paris.

**1874** Exhibits three paintings in the first Impressionist exhibition; also participates in the group's exhibitions in 1876 and 1877.

**1877** His works begin to be acquired by fellow artists and a small group of collectors.

**1882** A single work is accepted at the Salon.

**1886** Cézanne and Hortense Fiquet marry. His father's death brings him a considerable inheritance, including property at Jas de Bouffan.

**1889** *The House of the Hanged Man* (page 153) is included in exhibition of French art at the Paris world's fair; Cézanne participates in shows in Brussels and Copenhagen.

**1890** Participates in annual exhibition of "Les XX" (The Twenty) in Brussels.

**1891** Publication of articles about Cézanne by Emile Bernard and the critic Joris-Karl Huysmans; recognition of his influence on younger artists begins.

**1893** Gustave Geffroy publishes an article mentioning Cézanne as a seminal figure in current painting.

**1895** November—first one-man exhibition, approximately fifty works, at Galerie Ambroise Vollard, Paris; Edgar Degas, Monet, and Renoir buy works. (Cézanne also has shows there in 1898 and 1899.) His works begin to sell with some regularity, for modest amounts.

**1897** Cézanne's mother dies.

**1899** Sells Jas de Bouffan; has new studio built in his house in Aix. Participates in the Salon des Indépendants.

**1900** Included in exhibition at Cassirer Gallery, Berlin.

**1901** Included in the Free Aesthetic exhibition, Brussels (and again in 1904); Salon of the Society of Fine Arts, Béziers, France; first International Exhibition, the Hague; and Seventeenth Exhibition of Independent Artists, Paris.

**1902** Health starts to fail.

**1903** Included in two exhibitions in Vienna; participates in Salon d'Automne, Paris.

**1904** Receives his first visit from Emile Bernard and they initiate a correspondence. Has a one-man exhibition at Cassirer Gallery,

Berlin. The second Salon d'Automne devotes an entire room to his works. His importance is cited in articles by Bernard and several books on Impressionism.

**1905** Exhibition of his watercolors at Galerie Vollard; ten works included in Salon d'Automne (and again in 1906). An article by Pierre Hepp acknowledges Cézanne's significance for the new generation of artists.

**1906** Included in exhibition at Cassirer Gallery, Berlin, and French Impressionist painting exhibition at Kaiser Friedrich Museum, Posen, Germany. Health worsens; October 23—dies in Aix.

# SUGGESTIONS FOR
# FURTHER READING

Cachin, Françoise, and Rishel, Joseph J. *Cézanne.* Paris: Réunion des Musées Nationaux; Philadelphia: Philadelphia Museum of Art, 1995.

Fry, Roger. *Cézanne: A Study of His Development.* 1927. Reprint, Chicago: University of Chicago Press, 1989.

Gowing, Lawrence. *Cézanne: The Early Years, 1859–1872.* New York: Harry N. Abrams, 1988.

Rewald, John. *Cézanne: A Biography.* New York: Harry N. Abrams, 1990.

Rubin, William, ed. *Cézanne: The Late Work.* New York: Museum of Modern Art, 1977.

Schapiro, Meyer. *Paul Cézanne.* New York: Harry N. Abrams, 1952.

——. "The Apples of Cézanne," in *Modern Art.* New York: George Braziller, 1978.

# INDEX OF DONORS' CREDITS

The Henry P. McIlhenny Collection in memory of Frances P. McIlhenny: 121

Bequest of Marion Koogler McNay: 140, 228

Collection of Mr. and Mrs. Paul Mellon: 30, 33, 131, 173

Gift of Eugene and Agnes E. Meyer: 95, 145, 224

R. T. Miller, Jr., and Mrs. F. F. Prentiss Funds, 1950: 179

The Saint Louis Art Museum, Museum Purchase: 214

Bequest of Robert Treat Paine, 2nd: 102

Gift of Mr. and Mrs. Charles A. Ribbel, 1936: 227

Gift of Paul Rosenberg and Co., 1962: 207

Mr. and Mrs. Martin A. Ryerson Collection: 195

Bequest of John T. Spaulding: 176

The Louis E. Stern Collection: 56, 109

The Ella Gallup Sumner and Mary Catlin Sumner Collection Fund: 255

Bequest of Robert H. Tannahill: 90

The Thaw Collection: 242

Adaline Van Horne Bequest: 39

Wallis Foundation Fund in memory of Hal B. Wallis: 210

W. P. Wilstach Collection: 273

Wolfe Fund, 1951, from the Museum of Modern Art, Lillie P. Bliss Collection: 28

Ella C. Woodward and A. T. White Memorial Funds: 188

# INDEX OF ILLUSTRATIONS

282

283

# PHOTOGRAPHY CREDITS

Editor: Nancy Grubb
Designer: Kevin Callahan
Production Editor: Meredith Wolf
Production Manager: Lou Bilka

First edition
10 9 8 7 6 5 4 3 2 1

*Library of Congress Cataloging-in-Publication Data*
Wilkin, Karen.
    Paul Cézanne / Karen Wilkin.
        p. cm.
    Includes bibliographical references and index.
    ISBN 0-7892-0124-0
    1. Cézanne, Paul, 1839-1906—Criticism and interpretation.
I. Title.
ND553.C33W55 1996
759.4—dc20                                              95-50343

# SELECTED TINY FOLIOS™ FROM ABBEVILLE PRESS

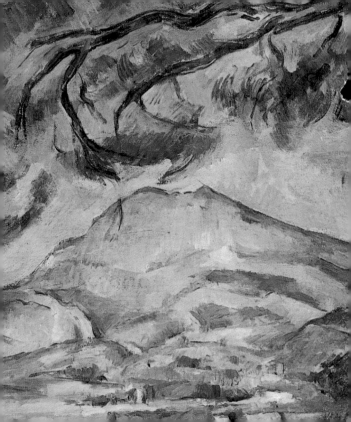

# PAUL CÉZANNE